Jan Steen

THE DRAWING
LESSON

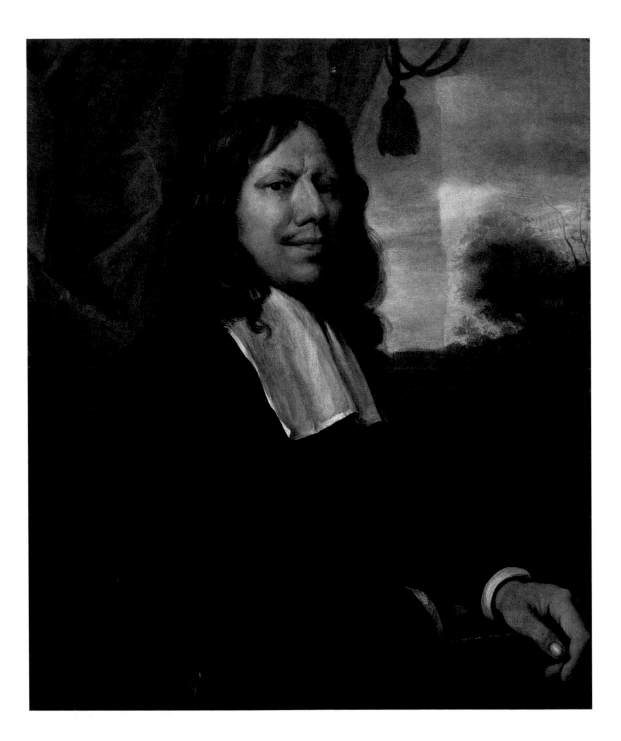

Jan Steen

THE DRAWING LESSON

John Walsh

GETTY MUSEUM
STUDIES ON ART

LOS ANGELES

For my teacher Julius S. Held in gratitude

Christopher Hudson, *Publisher*
Mark Greenberg, *Managing Editor*

Mollie Holtman, *Editor*
Stacy Miyagawa, *Production Coordinator*
Jeffrey Cohen, *Designer*
Lou Meluso, *Photographer*

© 1996 The J. Paul Getty Museum
17985 Pacific Coast Highway
Malibu, California 90265-5799

Mailing address:
P.O. Box 2112
Santa Monica, California 90407–2112

Library of Congress
Cataloging-in-Publication Data

Walsh, John, 1937–
 Jan Steen : the Drawing lesson / John Walsh.
 p. cm.—(Getty Museum studies on art)
 Includes bibliographic references.
 ISBN 0-89326-392-4
 1. Steen, Jan, 1626–1679 Drawing lesson.
 2. Steen, Jan, 1626–1679—Criticism and
 interpretation. I. Title. II. Series.
 ND653.S8A64 1996
 759.9492—dc20 96–3913
 CIP

Cover:
Jan Steen (Dutch, 1626–1679). *The Drawing
Lesson*, circa 1665 (detail). Oil on panel,
49.3 × 41 cm. (19⅜ × 16¼ in.). Los Angeles,
J. Paul Getty Museum (83.PB.388).

Frontispiece:
Jan Steen. *Self-Portrait*, circa 1665.
Oil on canvas, 73 × 62 cm (28¾ × 24⅜ in.).
Amsterdam, Rijksmuseum (SK-A-383).

All works of art are reproduced (and photographs
provided) courtesy of the owners unless other-
wise indicated.

Typography by G & S Typesetting, Inc.,
Austin, Texas
Printed by Typecraft, Inc., Pasadena, California
Bound by Roswell Bookbinding, Phoenix,
Arizona

CONTENTS

Final page folds out,
providing a reference color plate of
The Drawing Lesson

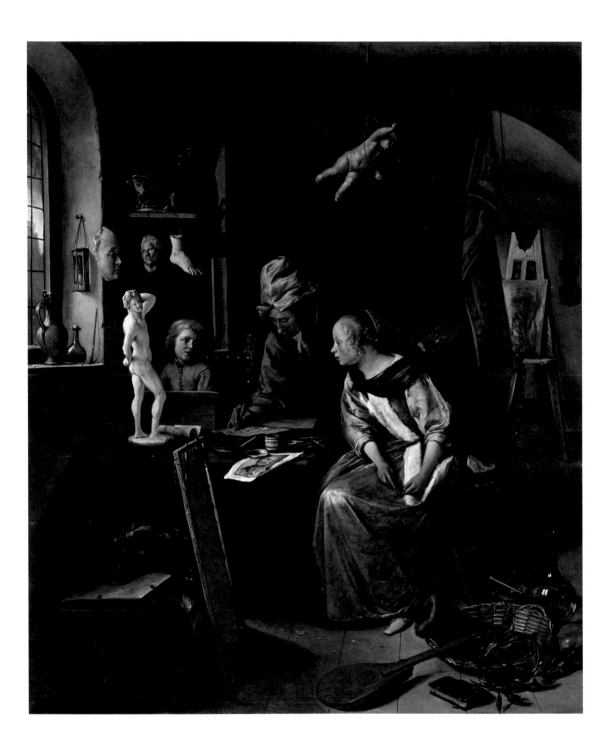

INTRODUCTION

In a spacious vaulted room a painter leans over to correct a drawing by one of his two pupils, a young boy and a beautifully dressed girl, who look on [FIGURE 1 *and* FOLDOUT]. In great profusion studio props appear everywhere in the room: plaster casts of sculpture, equipment for drawing and painting, a still life on the floor. It is all clear, solid, palpable. Soft light, slanting into the room from two windows, defines the people and objects against the surrounding half shadows. The light makes crisp edges, it caresses the receding planes of the floor and table, it saturates the colors of the girl's costume and gives them an alluring richness.

To present-day audiences this is a surprisingly familiar world, the Dutch interior of three centuries ago: a world of serenely geometrical closed rooms with window light that is easily recognized from countless reproductions of pictures by artists such as de Hooch and Vermeer [FIGURE 4]. The well-known wizardry of the Dutch painter is here to be wondered at: he summons up appearances with eerie success, simulating surfaces, making us believe in the reality of the solid things we can see and the immaterial light and air we cannot. And all of this comes across even more strongly in *The Drawing Lesson* because it is in pristine condition, having lost little of its original subtlety of color and tone in the three centuries since it was made.

The Drawing Lesson has surprises for everyone who looks at it, no matter how experienced or inexperienced. The subject, an artist in the act of teaching (something many Dutch artists spent a lot of time doing) is very rare among the tens of thousands of Dutch paintings of daily life. The technique of the picture is refined, a surprise for those who know Steen's work and expect more painterly execution. And the straight-faced, even solemn tone in which the scene is treated is a surprise for those who are used to Steen's more familiar and typical pictures and expect some sort of humor, whether boisterous or sly, in whatever subject he paints. Here, however, Steen's intentions are serious. Beyond giving a visual inventory of the contents of a studio, beyond evoking the

I

atmosphere of the room, beyond conveying the expressions and body language of the people, Steen meant this picture to be a celebration of his profession. Just how rich and thoughtful it is will not be apparent until we have seen something of the context in which the painting existed in its own era. And by looking at the history of the ideas in Steen's picture and in others by his contemporaries, we can measure his originality.

The purpose of this book is to explore *The Drawing Lesson*, alternately moving in for close inspection and backing off to see the larger patterns. My role will be that of conductor—to switch to a musical metaphor—looking at individual passages, rehearsing the parts, then trying to restore overall sense to the composition by playing the whole thing. By sense I mean historical sense: not merely a pleasing contemporary rendition but a reasonably consistent and well-supported account of the associations or meanings the picture would have had for the artist and his audience. A good deal of humility is in order here, for there is a limit to our ability to restore the original sense of anything three centuries old, especially a work of art whose technique is metaphorical, allusive, sometimes purposely ambiguous. Just as the music we hear is reinterpreted through each playing, and every piece is hostage to the performer's biases and particular understanding, so the interpretation of works of art, which themselves appear deceptively constant, is in good measure a construct of our own that has been shaped by our contemporary expectations and our changing conception of the values of the past. Parts of my own interpretation of *The Drawing Lesson* are sure to be outdated by new knowledge and made old-fashioned by changes of attitude. With this in mind, however, there is much we can do to understand the picture better.

Let us begin by looking at the life *The Drawing Lesson* has led since it was painted, which has been eventful and sometimes revealing. The bit of information we would most like to have, however—the identity of its first owner—is still unknown. The distinctive subject suggests that the picture may have been painted at the request of someone with an interest in painting or the teaching of artists; if so, the patron may well have had an influence not only on Steen's choice of subject but also on the way he treated it. It is possible that the picture belonged fifty years later to the wealthy and sophisticated Leiden collec-

tor Petronella Oortmans-de la Court, who owned a painting described in her inventory of 1707 as "a draftsman in an atelier by Jan Steen" that was sold a few months later for a respectable 105 guilders, but since there are several other paintings by Steen that could fit this description, we cannot be sure.

The first appearance of the picture for which we have a document was an auction sale of the property of François van Hessel in Amsterdam in 1747, where it made a good but unsensational price, 255 guilders. At some time before 1781 it had left Holland for France and belonged to the duc de La Vallière, who sold it in February of that year with a group of mostly Dutch paintings. *The Drawing Lesson*, billed as "one of the masterpieces of this skillful painter," went to an unknown buyer for a respectable 1,800 francs. But much bigger prices were paid at the same sale for other Dutch pictures of similarly refined finish, which were being collected avidly in France in those years (a van der Heyden canal scene went for 6,000 francs and a Teniers for 5,500). Steen's painting was again up for auction in Paris three years later and did not do quite as well: it sold for 1,400 livres (about the same as francs) to the dealer L.C. Desmarest, an active figure in the Paris art market in those years.

We are in the dark about the whereabouts of *The Drawing Lesson* after 1784. When, less than a half century later, John Smith published a pioneering catalogue of all the known works by leading Dutch and Flemish artists he could not report where *The Drawing Lesson* had gone, and the picture did not reappear until around 1897 to 1907, when it passed through the hands of various London art dealers.

By 1913 it had found a serious collector, the Frankfurt banker A. de Ridder, who kept it is his villa at Cronberg in the Taunus Mountains. Its sojourn with de Ridder gives a glimpse of the mechanisms by which art collections were formed, promoted, and dispersed during the early twentieth century, an era of active collecting by Germans before World War I, then by Americans afterward. De Ridder had the advice of Wilhelm von Bode, director of the Kaiser Friedrich-Museum in Berlin and the most powerful museum director of his time. Bode gave expertise and encouragement to many rich German merchants who were newcomers to collecting, and in return he got gifts for his museum. (This should sound familiar to Americans, for it was the prototype of the symbiosis

between collectors and curators that has been responsible for the formation of American museum collections.) Bode was the author of a sumptuous catalogue of the collection commissioned and produced by de Ridder. The collection was shown in 1913 at Kleinberger, a New York gallery. After de Ridder's death just before World War I, the collection was sequestered as German property in Paris, then sold at auction in June 1924. The sale was made into a major event, promoted by a barrage of hoopla using methods that have since become common in the auction business: a special catalogue, flyers in English, heavy newspaper publicity, and color plates in a popular magazine. *The Drawing Lesson* was knocked down to the same dealer, Kleinberger, who had shown the collection in New York before the war for 210,000 francs—not a bad price, but less than the sum fetched by a larger genre painting by Steen and a fraction of the 1,320,000 francs paid by Andrew Mellon for a Meindert Hobbema landscape and the 2,100,000 laid out by Joseph Duveen for a portrait by Frans Hals.

Kleinberger sold *The Drawing Lesson* in 1926, not to an American but to the Danish collector A. Reimann. Reimann lent it to Steen exhibitions in Leiden in 1928 and The Hague in 1958, and again in 1964 to an exhibition in Delft devoted to representations of painters and their studios. These brief public appearances earned the picture some of the popular attention it deserved. After nearly sixty years in Denmark, the painting was bought by the London dealers Edward and Anthony Speelman and was soon sold by them to the Getty Museum, which shortly before had begun to enjoy the use of the immense endowment left by its founder, J. Paul Getty. The picture would have been a good acquisition at any period in history, but in the 1980s its particular qualities were bound to make it more desirable than at any time in the past. Its untypical seriousness appeals to a generation that has learned to value Steen's history paintings and has developed a taste for pictorial allegory. And its refined style suits our time, in which the once-famous Leiden painters of highly finished genre scenes (*fijn-schilders*) have been rediscovered. Thanks to the waning of the cult of loose brushwork that was the legacy of the triumph of Impressionism, careful finish is no longer seen as evidence of academic pedantry, and museum-goers, sophisticated and unsophisticated alike, are once more ready to take pleasure in such meticulously painted pictures as *The Drawing Lesson*.

A Familiar Face

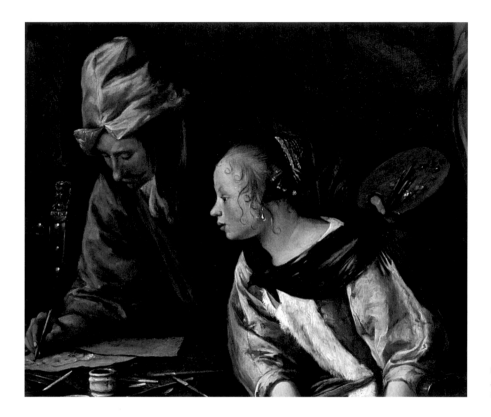

THE PAINTER'S IMAGE

The artist in the Getty painting is not Jan Steen himself. An actual self-portrait of around the same time [FRONTISPIECE] represents somebody else, a man with a similarly fashionable moustache but with thicker features than those of the painter in the studio, who has a long straight nose and pointed chin [FIGURE 2]. This is neither a portrait of Steen in *The Drawing Lesson*, nor indeed any par-

ticular Dutch artist, but instead a generalized type: The Painter. Just as Adriaen van Ostade personified the landscape painter by an anonymous figure in fancy dress seen from the back [FIGURE 3], and as Vermeer embodied the history painter in his familiar allegory [FIGURE 4], Steen represented the painter in the guise of teacher.

Jan Steen's face is more familiar than that of any other Dutch artist except Rembrandt. As a young man Rembrandt occasionally portrayed himself as a character in his pictures, but most of his self-portaits are solo. With Steen it is the opposite: he is frequently an actor in his own scenes and changes costumes constantly: he is a drinker and hell-raiser in scenes of carousing; he is a fool; he is the prodigal youth whose whoring and time-wasting are good for entertainment and supply a message. Sometimes he is the witness who points out the moral to the spectators. In one painting he paints himself in the guise of a stage musician who delivers his hopeless love song with a hopeful grin [FIGURE 5]. Steen's ubiquitous presence in the company he paints gives his work a character all its own, especially since it so often depicts a world of joyous excess in which Steen is the host, the sponsor, the egger-on of follies. What sort of man was this?

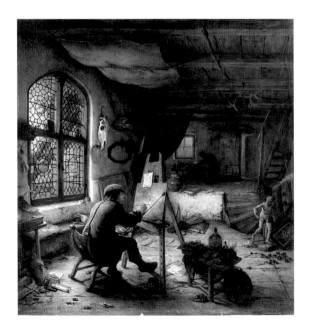

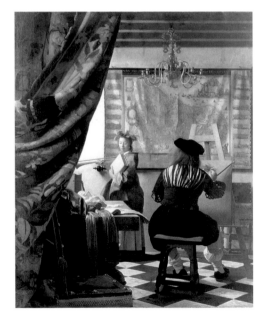

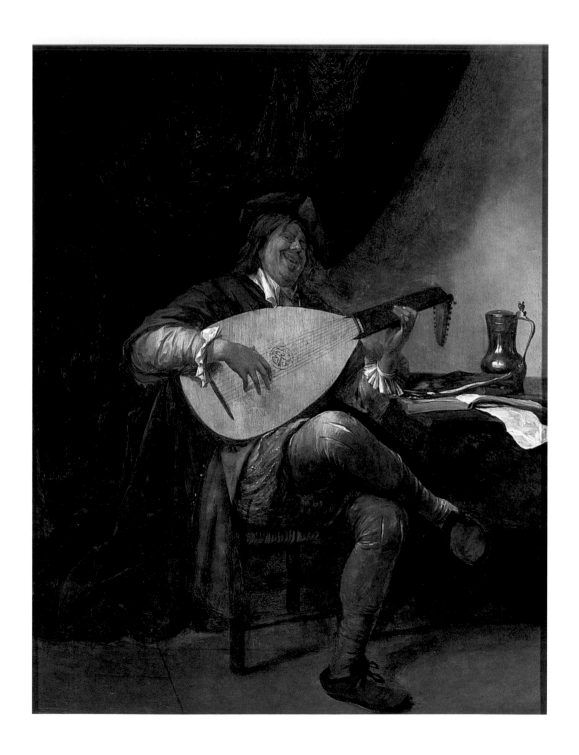

His first biographer, Arnold Houbraken, had no doubt that Steen lived like the hell-raiser in the pictures: "His paintings are like his way of life and his way of life like his paintings." In fact much of Houbraken's life of Steen (1721) consists of anecdotes that resemble the paintings. This should not be surprising since Houbraken, writing fifty years after Steen's death, had little more to go on than the paintings, the shop talk, and the biographical fact of Steen's part-time activity in brewing and tavern-keeping. In describing Steen as a drinker and gambler with a love of coarse comedy, Houbraken drew his material from the pictures themselves, such as the one he called "an emblem of his disorderly household," as if it pictured Steen's own house:

> The room was a topsy-turvy mess, the dog eating from the pot,
> the cat making off with the bacon, the children rumbling around
> on the floor, the mother sitting comfortably in a chair watching
> all this, and as a farce, he painted himself there too, with a roemer
> in his hand, while a monkey on the mantel stared with a long face.

A "Jan Steen household" is still part of the Dutch language to this day.

Identifying Steen with the scenes he painted came naturally to a biographer who regularly demonstrated the general belief of his time that art ought to spring from the artist's own disposition and reflect his personality. This conception of a wastrel Steen continued to suit the writers of the following century who first assembled the history of Dutch painting. Romantic rebels against bourgeois hypocrisies such as the poet Heinrich Heine, who called Steen "the apostle of the religion of pleasure," were pleased to detect evidence of bohemianism in artists they admired.

But was Steen really the feckless hedonist that his early biographers imagined? There is no hard evidence for this. The facts of his life reveal instead a pattern of solid respectability. Did the respectable Steen merely use himself as a handy (and free) model? Was he simply the victim of imaginative biographers who had their own theories and books to peddle? To some extent, perhaps; but they were surely taking their cue from the persona Steen created in the pictures themselves, the perpetrator of domestic chaos and proverbial folly. We have to

suppose that the painter included himself in some of these stock guises of comic actor, fool, and latter-day Prodigal Son for the same purposes as other artists had earlier, in order to sharpen the moral of the picture or to comment on it. Rembrandt had painted himself as one of Christ's executioners in a scene of the Raising of the Cross, embodying the idea of his (and our) complicity in the terrible act and emphasizing the validity of its lesson in his own time. In the same spirit he had painted himself as a Prodigal Son in modern dress. It is typical of Steen to have taken from other artists' work a device that was so pregnant with possibility, and he exploited it again and again, fashioning out of his frequent presence in his paintings a kind of trademark. By doing so he was advertising his own ability to spot and expose human foolishness.

STEEN'S LIFE

Jan Haviksz. Steen died in 1679 at the age of about fifty-two in Leiden, the city where he was born. He had painted for thirty years in half a dozen places, none more than thirty miles from his birthplace, and there is no evidence that he ever left the northern Netherlands. In November 1646 Steen was inscribed as a student at the University of Leiden. From this we can assume that he would have spent the previous seven years or so at Latin school—not apprenticed to a painter at an early age like the boy in *The Drawing Lesson*. This much formal education was most unusual for an artist. Twenty years earlier, Rembrandt had been one of the few Dutch painters-to-be to enroll in a university. But Steen's time there, like Rembrandt's, was evidently brief because there is no further mention of him, and we can suppose that he registered not to get an education but to qualify for the various benefits Leiden conferred on students, including exemption from certain taxes and service in the militia.

The next date we have for Steen shows that by March 1648 he had become a master painter, for he was among the first members to inscribe themselves in the new painters' guild in Leiden, the Guild of Saint Luke. To qualify as a master so quickly, he must have had an accelerated period of training and apprenticeship to another master.

It was in Haarlem that he evidently made this progress and served this apprenticeship. In between Leiden and Haarlem, however, he made a trip to Utrecht to study with Nicolaes Knupfer, according to one of his eighteenth-century biographers, Weyerman. Knupfer was an artist of real brilliance whose theatrical paintings of classical and biblical history ought to have made an impression on Steen if he saw them as a young man [FIGURE 6]. Although his own history paintings do not reveal any influence from Knupfer until much later, the trip to Utrecht in Steen's early years nevertheless does seem likely, to judge from the impression several other Utrecht painters made on him.

It was in Haarlem that Steen must have learned the most. Weyerman says that he was a pupil of Adriaen van Ostade, the prolific painter of peasant scenes, and it is obvious that the work of Adriaen's brother Isaac was important to him. Steen's earliest pictures are unmistakably the work of a talented artist who had absorbed the Haarlem tradition of small-figured scenes of markets, drinkers, fortune-tellers, travelers inside and outside inns, peasant festivals, and other lively aspects of ordinary life, often set in luminous landscapes—pictures for which there was an established market [FIGURE 7].

Steen married Margriet van Goyen, the daughter of the great landscape painter Jan van Goyen, in the autumn of 1649 in The Hague, where he seems to have lived until 1654. There are no dated pictures until 1651, and few thereafter, so Steen's earliest development is not easy to trace; but it was rapid enough to establish him as a prolific painter of ambitious compositions by the age of twenty-five or so. At some point he had contact with the history painter Jacob de Wet, whose small-figured historical compositions he must have studied and whose example he followed. Steen was among the few genre painters who also treated the more elevated category of biblical and historical subjects.

Jan's father, Havick Steen, a grain merchant and brewer, guaranteed his son's lease of a brewery called "de Slange" (The Serpent) in Delft between 1654 and 1657. Despite this, and the fact that he painted a leading citizen of Delft in 1655, it is not certain that Steen actually lived in Delft, which is only about five miles from The Hague. The so-called *Burgomaster of Delft and His Daughter* of 1655 [FIGURE 8], ambitious in its architecture and assured in its subtle effects, is entirely in the spirit of Steen's older Delft contemporaries

Figure 6
Nicolaes Knupfer (Dutch,
circa 1603–circa 1660).
Solon Before Croesus,
circa 1650–52. Oil
on panel, 61 × 89.9 cm
(24 × 35 3/8 in.).
Los Angeles, J. Paul Getty
Museum (84.PB.640).

Figure 7
Jan Steen. *Dancing
Peasants at an Inn*, circa
1648. Oil on panel, 40 ×
58 cm (15 3/4 × 22 7/8 in.)
The Hague, Mauritshuis.

Figure 8
Jan Steen. *Portrait of a Man with a Girl and Beggar* (*"The Burgomaster of Delft"*), 1655. Oil on canvas, 81.5 × 68.5 cm (32 ⅛ × 27 in.). Great Britain, private collection (Photo: London, National Gallery).

Carel Fabritius and Gerard Houckgeest, and may even have contributed something to the famous pictures of courtyards and canals painted by Pieter de Hooch a few years later.

Steen is mentioned in several Leiden documents of 1654, so he may have returned by then. By 1656 he was living in a small house in Warmond, three miles from Leiden. He was a friend of Frans van Mieris [FIGURES 30, 31], the leading artist of the second generation of Leiden *fijnschilders* whose work was the legacy of Rembrandt's activity in the city and that of his pupil Gerard Dou. Steen had returned to Haarlem in 1661, when he joined the painters' guild and remained until 1670. It was in Haarlem that he painted the Getty picture and many of his most successful mature works. In 1669 his wife Margriet died, and in

the following year his father. The tight circle of Steen's travels closed in 1670, when he came back to Leiden and remained there for the last nine years of his life. Only in his last decade do we have documents about his finances, which were evidently shaky. Steen had to cope with a bad market for beer and for pictures, owing to the effects of the naval war with the English in the 1650s and 1660s, then of the war with the French in the 1670s. He was by no means the only artist forced in these hard years to ply a second trade. He settled several small debts using paintings that were credited at less than ten guilders each, the low prices indicating that either these were modest pictures or Steen was hard-pressed. In 1672 he requested and got permission from the Leiden city fathers to keep a tavern. Whether he actually did so is not documented, but his eighteenth-century biographers assumed that he did and made a great deal of his presumed experience as a genial host, not to say carouser. This seems to be based on Steen's paintings, not on any documented facts of his life; in any case, Steen's moral character and standing in society were sufficiently esteemed by the Guild of Saint Luke for him to have served as *hooftman*, or leader, three times, and in 1674 as *deken*, or dean.

Steen was remarried in 1673, six years before his death, to the widow Maria van Egmont, who bore the last of his seven children.

STEEN'S CHARACTER AS AN ARTIST

Steen painted a very large number of pictures, of which almost four hundred have survived. In addition, hundreds more paintings ascribed to him are known today only from documents. This is the largest body of work by any Dutch figural artist, and although there are many small paintings and some hastily painted potboilers among this mass, the sheer numbers are impressive.

The artist in the Getty painting is teaching pupils to draw. Steen himself did not teach, evidently, for if he had we would expect to find contracts between Steen and his pupils or their parents, but none have turned up in the archives, and nowhere in the documents or biographies is he mentioned as the teacher of another artist.

Furthermore, Steen rarely drew. There is only one drawing certainly by him, a study for figures in an early outdoor genre painting [FIGURE 9]. There is another drawing believably attributed to him, an elaborate composition related to his painting *The Trial of Infant Moses* [FIGURE 10], which may have been made because of unusual circumstances, to show the composition to the patron who commissioned the work. This near-total absence of drawings is unusual for a history painter (although there are many genre painters by whom no drawings are known). It seems likely that Steen, having drawn as a pupil and a young artist, dispensed with preparatory drawing as a regular practice and instead laid out compositions directly on the canvas.

Not only has Steen no rival among Dutch painters for the number of ambitious figure paintings he produced, he stands alone in the range of subjects he treated—high and low, historical and contemporary, refined and crude, sacred and profane. To be this prolific and versatile took organization as well as technique. It took an education, a practical knowledge of the imagery of earlier art, and a curiosity about folkways and proverbs. Steen's eyes were open to the art of his contemporaries as well, and he absorbed the lessons of the leading painters in his travels—particularly in Leiden, Haarlem, and Delft—and assimilated

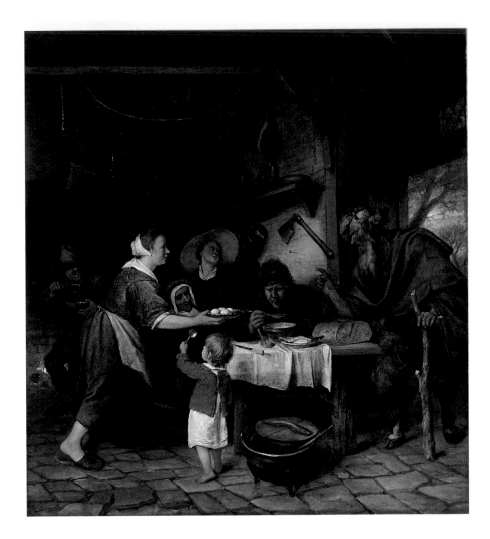

Figure 11
Jan Steen. *The Satyr
and the Peasant's
Family*, circa 1660–62.
Oil on canvas, 51 ×
46 cm (20 × 18⅛ in.).
Los Angeles, J. Paul
Getty Museum (69.PA.15).

them into his own idiom. Pieter de Hooch and Adriaen van Ostade have already
been mentioned; a few more examples will give a picture of Steen's ability to
synthesize other people's ideas and create something fresh.

A painting in the Getty Museum [FIGURE 11] that looks at first
glance like an everyday scene of peasants at home actually represents one of
Aesop's fables: a satyr who is a guest in a human household watches his host
blow on his hands to warm them up, then blow on his soup to cool it off, and

takes fright at these strange creatures who can blow hot and cold. This good-natured warning against human unreliability was rarely illustrated, except by the Antwerp painter Jacob Jordaens [FIGURE 12], who produced at least a dozen versions of the subject. In Steen's youth Jordaens was the best living exponent of a tradition of illustrating folk wisdom in paintings that went back to Pieter Bruegel and earlier. Steen seized on that tradition and gave it new life.

In a large canvas in the Mauritshuis [FIGURE 13], a family enjoys itself at the table as an old woman points to a paper and reads the words "Soo voer gesongen, soo na gepepen." This is a proverb; roughly, "As the old birds sing, the young ones peep"—like father, like son. The metaphor of piping is turned into a pun by the laughing man who treats a young boy to a drag on the clay pipe: in Steen's world, initiation leads to trouble. Again Steen's model was Jordaens, who had painted the same subject twenty-five years earlier. Steen again went to the deep well of northern European folk wisdom about human folly that continued, like Aesop and the Bible and Roman history, to supply the seventeenth century with entertainment and instruction.

Figure 12

Jacob Jordaens (Flemish, 1593–1678). *The Satyr and the Peasant's Family*, circa 1618–20. Oil on canvas, 171.7 × 194 cm (67 5/8 × 76 3/8 in.). Kassel, Staatliche Kunstsammlungen (1769/318).

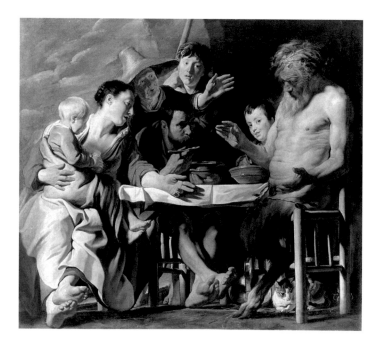

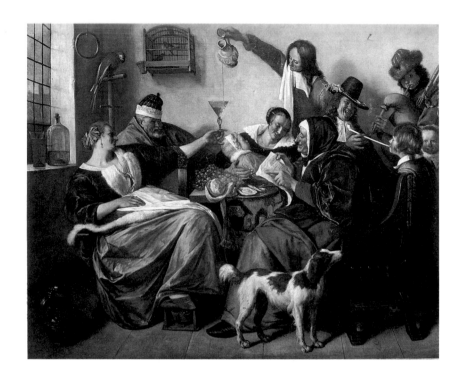

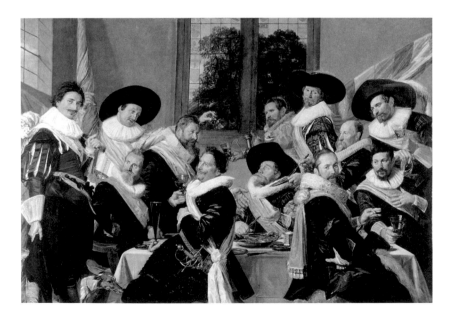

Steen was not only resourceful at reviving subjects, he was masterful at staging and directing them. The characters use their bodies and faces to express a whole gamut of attitudes, yet even in the most complex compositions, where disorder is the theme, Steen's designs are highly organized. The Mauritshuis painting is pulled together by a web of lines that converges on the ceremonious pouring of a glass of wine. Here the example of Hals's highly orchestrated banquets [FIGURE 14], which Steen would have studied in Haarlem, certainly stuck. This process of organizing a multitude of energized figures into a coherent tableau that tells the story was a preoccupation of painters all over Europe during the seventeenth century, and Steen is one of the greatest practitioners.

The Mauritshuis painting was called *Jan Steen's Household* in the nineteenth century, for the laughing man with the pipe, the corrupter of youth, has Steen's features. Granted that this isn't Steen's own family, what are we to make of Steen's presence here? Not a confession of his loose living, I imagine, but a claim that as a participant he really knows what is going on here and paints it with authority. He is a tempter in two ways: his comic double tempts the child, and his painter self creates a picture that offers pleasures for the senses that may get *us* in trouble if we overindulge.

Steen's popular reputation is based on pictures of rooms full of boisterous people misbehaving, but he painted a great many works of a different kind. After his return to Leiden and environs between 1654 and 1656, this supremely versatile painter adapted himself to producing a local Leiden specialty, small paintings with a few figures involved in more polite (if not more virtuous) goings-on, mostly having to do with love, in which the depiction of details and materials is fabulously refined [FIGURES 16, 17]. Gerard ter Borch's ample interiors with women dressed in shimmering satins were known to painters in Leiden and had a direct effect on Dou's successors there, including Frans van Mieris and Steen. I think that two elements of *The Drawing Lesson* that have the most immediate human appeal—the girl in profile and the boy with his head turned in her direction and lips parted—were not simply observed in live models and recorded by Steen but adapted from the similar motif in ter Borch [FIGURE 15, FIGURE 1 *and* FOLDOUT]. In the Getty painting the sheen of the girl's skirt, the texture of the fur trimming, and the precise observation of

Figure 15
Gerard ter Borch (Dutch, 1617–1681). *The Letter*, circa 1661. Oil on canvas, 79.5 × 68 cm (31¾ × 26¾ in.). London, Her Majesty Queen Elizabeth II (CW 29).

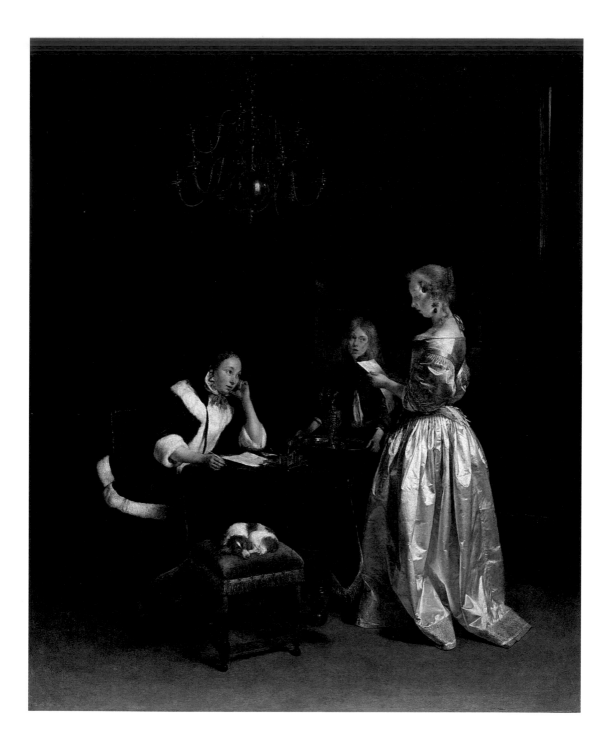

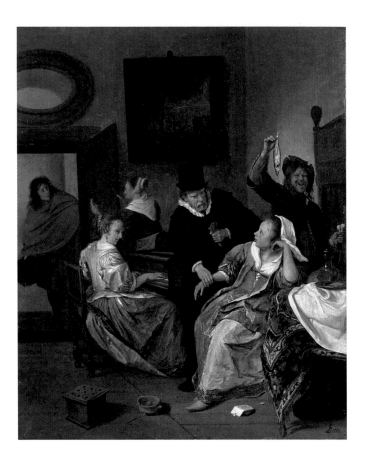

Figure 16
Jan Steen. *The Doctor's Visit*, circa 1660–65. Oil on panel, 46.3 × 36.8 cm (18⅛ × 14½ in.). Philadelphia Museum of Art (John G. Johnson Collection, no. 510).

details bear the trademark of the Leiden painters. But Steen rendered these things more broadly and summarily than Dou or van Mieris or Metsu, and he had a color sense uniquely his own.

Of all the Dutch painters, Steen is the readiest to blur the boundary between the everyday world and the worlds of classical and biblical antiquity, allegory, and theater. Satyrs turn up in the huts of Dutch peasants [FIGURE 11]. Doctors make house calls wearing the outlandishly old-fashioned costumes of quacks on the contemporary stage [FIGURE 16]. Slipped into otherwise realistic scenes of merrymaking are symbols of blindness, folly, beggary. Steen gives extra life and point to historical and biblical scenes by such blatant breaches

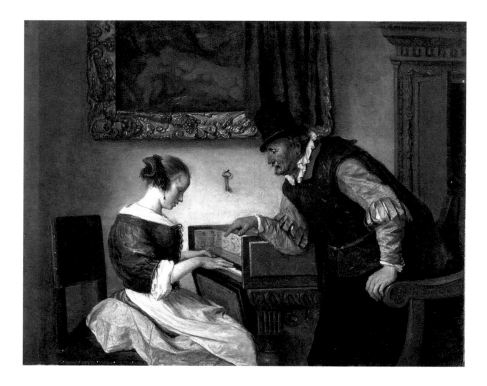

Figure 17
Jan Steen. *The Music
Lesson*, circa 1662–65.
Oil on panel, 37 ×
48 cm (14⅝ × 18⅞ in.).
London, The Wallace
Collection.

of traditional decorum as using unidealized models, adding crowds of unruly
extras, and inventing entertaining if gratuitous stage business. In doing this
Steen had good company, not just Knupfer and de Wet, but particularly Rem-
brandt, the great Leiden success story of the previous generation, whose prints
in particular Steen must have known well.

No other Dutch painter was as good at dirty jokes. These come in
a truly astonishing range: hoary platitudes about the sexual incompatibility
of youth and age (with many variants involving money, impotence, etc.); the
aphrodisiac power of oysters; surprise pregnancy; rough stuff in taverns and more
polite but equally commercial dealings in better-furnished bordellos; and on

and on. These scenes are played broadly or subtly, with a leer or with the most refined and straight-faced double entendres. *The Doctor's Visit* is the most often repeated of these [FIGURE 16], a subject Steen took from van Mieris and painted in many variants, all introducing a quack who, with a theatrical flourish, takes the pulse or examines the urine of a pretty girl. Everybody knows the outcome except the girl and sometimes the doctor; the pleasure comes in savoring the nuances of the comedy. What is going on in *The Music Lesson* is not so obvious [FIGURE 17]. The girl plays for an old man whose out-of-date theatrical outfit, like the physicians', identifies him as a figure of fun. Steen makes it plain that love is involved: hanging prominently on the wall just below a painting of Venus and Cupid is a key, literally the key to the meaning of the picture. But whose love, and what kind? The painting appears to be another variant by Steen on the age-old theme of the Unequal Pair of Lovers, but is he her music teacher, her would-be lover, or both?

The sacred and the profane are sometimes hard to distinguish in Steen's pictures. His Bathsheba, despite her historical costume, looks for all the world like a courtesan of Steen's time, and her servant looks like a procuress [FIGURE 18]. She has just read King David's summons, and unlike the conflicted Bathsheba painted by Rembrandt, she is an unabashed sex-object who casts her self-satisfied gaze right at the spectator as frankly as Manet's brazen Olympia.

To the academicians of the next century, Steen's mixing of high and low was not only ridiculous, it disqualified him as a history painter. Writing in 1774, Sir Joshua Reynolds recognized Steen's talent but diagnosed his problem as not being Italian and not having had the right masters:

> If this extraordinary man had had the good fortune to have been born in Italy instead of Holland; had he lived in Rome instead of Leyden, and been blessed with Michael Angelo and Rafaelle for his masters, instead of Brower and van Gowen; the same sagacity and penetration which distinguishes so accurately the different characters and expressions in his vulgar figures, would, when exerted in the selection and imitation of what was great and elevated in nature, have been equally successful; and he would have been ranged with the great pillars and supporters of our Art.

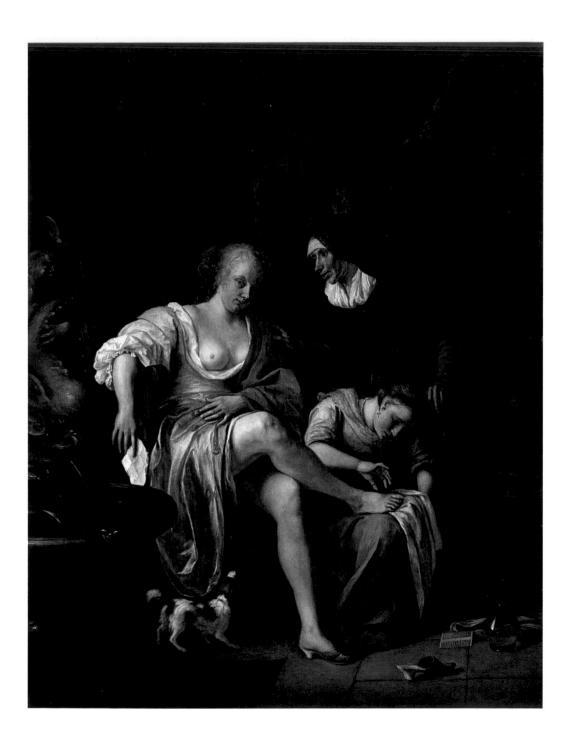

Common to most of Steen's pictures is an unusual degree of insistence on the moral of the tale. The moral may not be deep, it may be only an aged cliché (i.e., old men shouldn't make fools of themselves over young women; easy come easy go; wine is a mocker; a fool and his money are soon parted; and so on) but it is hard to escape, for Steen generally makes the point explicit by a gesture or a glance, occasionally performed by a man bearing Steen's own features [FIGURE 16]. Often someone is looking out of the picture to be certain that the spectator gets the message [FIGURE 64]. Steen's purpose was common to much of seventeenth-century Dutch painting, a combination of visual pleasure and moral instruction. The famous maxim of Horace, to please and to educate, seems to have guided artists in most categories of painting, if not all, but in just what proportions is rarely clear. This must vary from artist to artist, from subject to subject, and from picture to picture. Pleasing and educating were accomplished through a metaphorical language and a store of symbolic associations, however, that artist and audience had in common. Having lost the key to some of the symbolic language of pictures in the seventeenth century, and worse, having lost a reliable sense of the interrelationship of pleasure and moral instruction that was an everyday reality in Steen's time, we still have a lot to learn before Steen's intentions are clear. But there is no question that Steen's comedy, at least, served a serious purpose. It has parallels in the theater and the popular verse of his time, and it does not lack parallels in our own time, either. To quote a recent writer:

> Anyone who wants to regain some of the original spirit in which comic scenes like Steen's simultaneously teach and delight, might do well to watch a little television. Today's situation comedies—The Cosby Show, for example—are striking in their ability to teach lessons about serious ethical issues like drugs and racism, not to mention greed and vanity, in the context of silly plots and canned laughter.

The extroverted aspect of much of Steen's work is completely absent from *The Drawing Lesson*. But the picture could only have been painted by Steen.

The characters have a touching combination of earnestness and sensual soulfulness that is Steen's own. The technique has a particular combination of refined finish and solid, confident handling of paint. And it displays an inventive reuse of traditional subject matter. This last element needs more exploration.

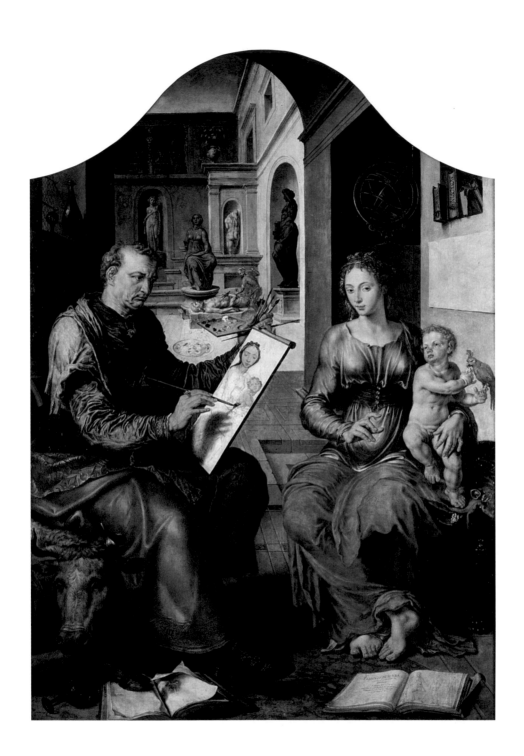

PICTURING THE WORKSHOP

WORKSHOPS, BIOGRAPHIES, AND STATUS SYMBOLS

Steen rarely invented new subjects. More often he refurbished old ones, as he did in the case of *The Drawing Lesson*. By the 1660s Steen had seen other paintings representing artists' workshops, some of them produced recently by the painters he knew in Leiden and Haarlem. These pictures constitute a century-old tradition that has to be considered in an attempt to understand Steen's picture.

When Maerten van Heemskerck painted Saint Luke portraying the Virgin and Child a century earlier [FIGURE 19], he set the scene in a grandiose palazzo that serves as a studio for Luke, the evangelist and physician who was also the patron saint of painters. The legend that the Queen of Heaven condescended to be portrayed by Luke was regarded all through the Middle Ages as evidence of the divine favor enjoyed by painters. Here both Luke and the art of painting are ennobled by the princely setting. No humble artisan, the painter-saint is a commanding figure whose face radiates intellectual force. To measure the advance over earlier images of Saint Luke, it is enough to compare Jan Gossaert's version of the subject: Luke kneels before a vision of the Virgin, and the angel who guides his hand makes it clear that Luke is directly inspired by God [FIGURE 20]. In the generation that separates these paintings, Heemskerck had traveled to Italy and been exposed not only to Roman antiquity but also to contemporary Italian ideas about the exalted powers of art. His conception of the ideal artist, based on that of Leon Battista Alberti and Leonardo da Vinci, is of a man of learning as well as manual skill whose powers of form-giving make him like the Creator.

Shouldn't these godlike powers earn recognition by the rich and powerful? In antiquity they had: Heemskerck and his fellow painters could read the stories told by Pliny the Elder about celebrated painters who were patronized by princes. Renaissance artists depicted their own princes doing likewise: thus a

Figure 19
Maerten van Heemskerck (Dutch, 1498–1574). *Saint Luke Painting the Virgin and Child*, circa 1553–60. Oil on panel, 205.5 × 143.3 cm (80⅞ × 56⅜ in.). Rennes, Musée des Beaux-Arts (801.1.6).

27

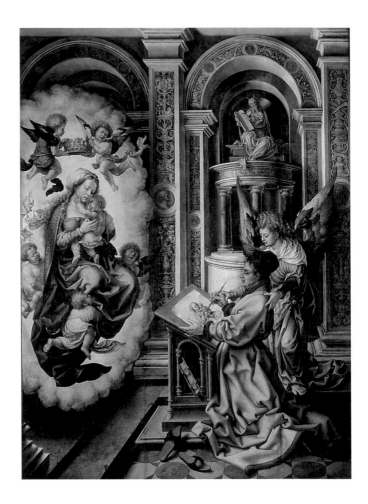

Figure 20
Jan Gossaert (Flemish, circa 1478–circa 1536). *Saint Luke Painting the Virgin and Child*, circa 1520. Oil on panel, 109.5 × 82 cm (43⅛ × 32¼ in.).Vienna, Kunsthistorisches Museum (894).

woodcut by Hans Burgkmair [FIGURE 21] shows the Emperor Maximilian (whose avid patronage of artists actually earned him this flattery) paying a visit to the workshop of a painter like a latter-day Alexander the Great in the atelier of his court painter Apelles. Now and then the Apelles story itself would be represented as an ideal for society, as it was in a drawing ascribed to the Amsterdam painter Werner van Valckert [FIGURE 22]. Painters of the later sixteenth century knew the success stories of their own time—Leonardo da Vinci a celebrity at the court of Francis I of France, Michelangelo's patronage by Pope Julius II, Titian turning down commissions by princes—not just from studio gossip but

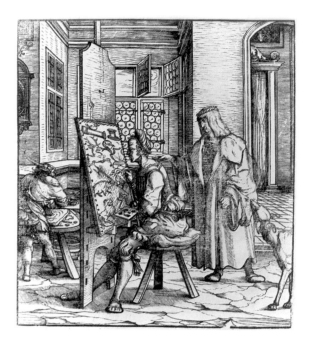

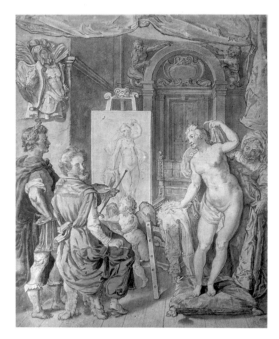

from books: for the first time they could read about them in a literature about art and artists. Giorgio Vasari's volume of artists' biographies (1550) and the book it inspired by the Dutch Karel van Mander (1604) celebrated this new ideal of the cultivated, well-to-do painter and the swath he could cut in the beau monde if he took the trouble to acquire the necessary social graces.

In service of the exalted new ideal of the artist came not only biography but also portraits, some of them self-portraits, and pictures of artists at work that satisfied a new curiosity about individual artists. Like biographies, the pictures were not merely descriptions of appearances, not simply claims for social status, but were also statements about art itself, carrying anything from subtle hints about the high standing of art to outright propaganda for it.

An openly didactic example is the painter's workshop engraved by Stradanus, the Flemish artist Jan van der Straet [FIGURE 23], who lived in Florence during Vasari's life and was familiar with the new Italian ideals as well as the older workshop practices of the northern Netherlands. The print illustrates

Figure 21
Hans Burgkmair
(German, circa 1473–?).
*The Emperor Maximilian
in a Painter's Studio.*
Wood block print, 22.2 ×
19.8 cm (8¾ × 7¾ in.),
from *Der Weisskunig*,
1514. New York,
Pierpont Morgan Library
(PML 4056).

Figure 22
Attributed to Werner
van den Valckert (Dutch,
circa 1585–after 1627).
*Apelles Painting
Campaspe*, circa 1620.
Pen and wash, 43.8 ×
45.2 cm (17¼ ×
17¾ in.). Amsterdam,
Rijksprentenkabinet
(1939:18).

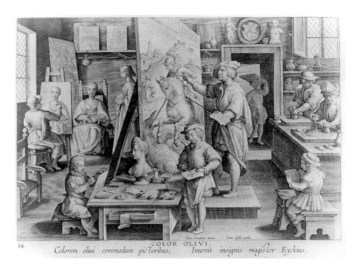

Figure 23
Theodor Galle (Flemish, 1571–1633) after Johannes Stradanus (Jan van der Straet) (Flemish, 1523–1605). *Color Olivi*, circa 1580. Engraving, 20.4 × 27 cm (8 × 10⅝ in.). The Fine Arts Museums of San Francisco, Aschenbach Foundation for the Graphic Arts (Purchase, 1966.80.73).

"color olivi," oil painting, whose invention was ascribed by tradition and by Vasari to Jan van Eyck, exemplified by a kind of ideal atelier in which the *chef d'école* paints a large picture of Saint George and the Dragon that is reminiscent of Raphael's version of the subject. Painting religious and historical subjects is the hardest task of the studio, so this is done by the master. At the left, a journeyman works on a portrait, and in the foreground, pupils prepare a palette for the master and practice drawing, one from a Roman bust. Workers grind pigment and mix paint at the right. This is a fair-sized business of eight people, each performing his appropriate task in an orderly and obviously prosperous workplace. The picture is not simply a survey of what goes on in an atelier but also a claim that the art of painting requires organization and a hierarchy of skills.

In David Ryckaert's painting of about 1650 [FIGURE 24] the message is different. The master is painting a humble subject, a man smoking a pipe in a landscape, for which the model is seated at the left. The atelier is utterly modest, but not its proprietor. He has the lace collar, ribboned stockings, plumed hat, and pet greyhound of a young patrician. The painting proclaims that while the simple setting may be appropriate to the modest subjects he paints, his art is nevertheless of an elevated nature, just as he is. Ryckaert's picture is a kind of

Figure 24
David Ryckaert III (Flemish, 1612–1661). *The Painter's Studio*, circa 1650. Oil on panel, 73 × 108 cm (28¾ × 42½ in.). Dijon, Musée des Beaux-Arts (J.126).

Netherlandish reply to a contemporary French engraving [FIGURE 25] depicting a
painter dressed to the nines and surrounded by pictures of noble subjects (what
the inscription calls "Tout ce que la Guerre et l'Amour / Ont de memorable et
d'estrange") while being visited by a splendid patron. He looks down his nose at
a print that, held out to him by a page, shows a poor painter in rags working
miserably at his easel, one of the "Peintres Vulgaires" of the inscription—like
Ryckaert's painter.

It is worth mentioning that not all the work that was performed in
artists' workshops is shown in seventeenth-century pictures. We see pupils
drawing, never painting, although they did; we see helpers preparing paints and
palettes but never doing other tasks such as framing pictures; we see the master
painting but not varnishing. In portraying their own work, artists did not intend
to be comprehensive. They were not cataloguing or describing so much as fol-
lowing a principle of "selective naturalness" (in the phrase of the seventeenth-

century painter and writer Samuel van Hoogstraeten) that served their purpose in making these pictures. As in every other category of Dutch art, their purpose was not primarily to illustrate but to exemplify.

These pictures of artists' studios all resemble one another in a general way, but they vary meaningfully in what they emphasize. Some, like the Stradanus engraving, put the act of painting in the foreground and give a lot of detailed information about how the workshop functioned. Others illustrate the business side of the operation, the showing and selling of paintings to clients. Others stress study and teaching, like Steen's picture. Still others are overtly allegorical and include personages and symbols from the realm of humanist symbolism. Often several of these elements are found in the same picture. A glance over the different varieties of atelier paintings will help to place *The Drawing Lesson* in the tradition to which it belongs.

The Workshop as Workplace

Paintings of ateliers proliferated partly because painters were growing more self-conscious, but of course this is not the whole story. They were also the product of a large-scale process of creating more subjects for painting. As scenes of daily life were finding an ever-expanding market in the late sixteenth and seventeenth centuries, artists diversified and enriched the subject matter, going back to older traditions or dreaming up new possibilities. Along with pictures of the idle pleasures of the well-to-do and the rougher fun of peasants, along with scenes of the festivals and folkways of society high and low, came paintings of respectable artisans—cobblers, tailors, weavers—at work in simple but impeccable interiors. The emphasis is on the facts of their occupations and on the implied virtue of plain lives devoted to work. (These are honest men, in contrast to the learned charlatans—the lawyers and doctors who gull the credulous and were a specialty of Steen.) Many atelier paintings have this upright character.

Adriaen van Ostade, Steen's teacher, shows a painter at work on a landscape in a large room that has a certain decrepit dignity [FIGURE 3]. There is a cloth hanging high above the easel to prevent dust from spoiling the wet painting, a pair of boys grinding pigment and preparing a palette, and a few props

Figure 26
Joos van Craesbeeck
(Dutch, circa 1606–
after 1654). *A Painter's
Studio*, circa 1640. Oil
on panel, 48.5 × 66 cm
(19⅛ × 26 in.). Paris,
Institut Néerlandais
(7087).

Figure 27
Jan Meinse Molenaer
(Dutch, 1645–1705).
A Painter's Studio,
circa 1631. Oil on
panel, 96.5 × 134 cm
(38 × 52¾ in.).
Staatlich Museen
zu Berlin, Preussischer
Kulturbesitz Gemäldega-
lerie (873).

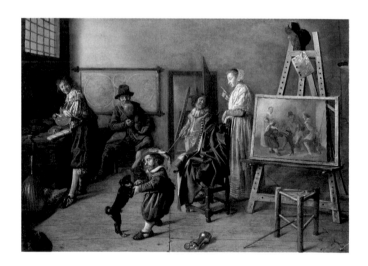

strewn about; but there are none of the attributes of the learned painter and
none of the patrician airs affected by Ryckaert's artist, who is in exactly the
same business [FIGURE 24].

Ostade's landscape painter is relying on a drawing he made in the
field, which he has pinned up on the easel. In other studio scenes the subject is
right in the room. Joos van Craesbeeck paints an atelier in which a genre painter

has begun to sketch the composition he has before him [FIGURE 26]: a group of fashionably dressed people indulging themselves around a table, drinking, smoking, and making music. At right is an abbreviated still life of books, globe, palette, and drawings that alludes to the painter and his learning. On one level the picture says that the artist takes the pains and expense to work directly from living models; on another, it may suggest that painting itself is vain since, like other indulgences of the senses, it pleases and deceives.

A more genial version of this idea is the 1631 painting by Jan Meinse Molenaer of models taking a break [FIGURE 27]. They have been posed for a scene of horseplay, and during the time it takes the good-humored painter to tend his palette, they keep it up. The picture implies not only that the painter's work is based on observation of live models but that the models he chooses are actually living their parts, not merely acting them.

A picture from around 1665–70 by Michiel van Musscher provides one more example of a how-it's-done atelier scene [FIGURE 28]. Van Musscher's

painter works alone at his easel and looks at drawings strewn on the floor. Since
the drawings depict various kinds of ships, he is evidently a sea painter, and the
picture may be a portrait of Willem van de Velde the Younger. Again it is the
relationship of the painter's work to its models that is portrayed and the artist's
thoughtful act of selecting and composing that is stressed.

The Workshop as Salesroom

Another type of atelier scene shows well-dressed visitors who examine the
artist's work, presumably as potential buyers as well as admirers.

In the seventeenth century, paintings were for sale at public mar-
kets, dealers, and auctions, but the most frequent transactions seem to have
taken place in the atelier. A collector went to look at the artist's work and
bought something ready-made, ordered a picture of a subject he wanted, or sat

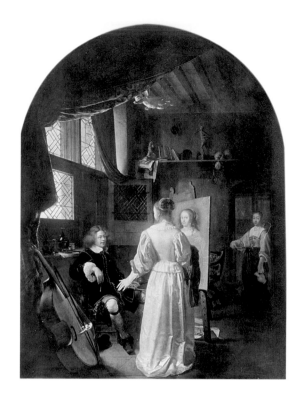

for a portrait. The journals of visiting foreigners reveal that they made the rounds of artists' studios when they arrived in Delft or Leiden or Amsterdam, and we can assume this was a common practice of residents as well.

Pieter Codde's painter [FIGURE 29] has three gentlemen in the shop examining pictures attentively. He is not a bit less fashionably dressed than his visitors, and he strikes a graceful pose. The unmistakable claim to status is like Ryckaert's [FIGURE 24]. In two studio scenes by Frans van Mieris the point is patronage, not workshop procedure. An artist shows a genre scene to a man who bends forward attentively to examine it [FIGURE 30]; in the other picture the artist, who has been painting a portrait of a woman, leans back with brush in hand as she examines it and makes a gesture that suggests surprise at the likeness [FIGURE 31]. In both pictures the spacious studio is equipped with the apparatus of a learned and cultivated artist, including plaster casts and a stringed instrument, and the artist is at ease, confident, and very well dressed.

Figure 30

Frans van Mieris (Dutch, 1635–1681). *A Connoisseur in an Artist's Studio*, circa 1660. Oil on panel, 63.5 × 47 cm (25 × 18½ in.). Dresden, Staatliche Kunstsammlungen (1751).

Figure 31

Frans van Mieris. *The Artist's Studio*, circa 1658–60. Oil on panel, 60 × 46 cm (23⅝ × 18⅛ in.). Formerly Dresden, Staatliche Kunstsammlungen (1750) (destroyed in World War II).

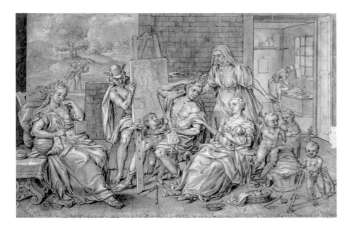

Most of these pictures that flatter artist and connoisseur alike repre-
sent the wished-for condition in which patronage is granted generously by dis-
cerning art-lovers to painters who are their social equals. It didn't always work
that way. The miserable opposite was illustrated by Heemskerck's contempo-
rary Marcus Geeraerdts [FIGURE 32]: a painter is harassed by Commerce in the
symbolic guise of Mercury, who hits him with the caduceus, and is plagued by
his wife and their crowd of little children. Sometimes the problem is a stupid
patron, like the one who wears eyeglasses and clutches his purse in a satirical
drawing by Pieter Bruegel, or another who sprouts ass's ears in a drawing by
Rembrandt. A drawing by the influential German painter Adam Elsheimer illus-
trates the extreme to which all this leads: surrounded by plaster casts and stu-
dio apparatus, importuned by his cat and dog while his hungry children peer
into the empty cupboard, the painter holds his head in despair [FIGURE 33].

PICTURA AND VANITAS IN THE WORKSHOP

We have seen painters propagandizing for the nobility of their trade with pic-
tures of contemporary ateliers frequented by patrons from the best society. So
far we have seen little that could not actually have been encountered in real life.
Sometimes, however, there is a distinguished visitor from another realm: Pic-
tura, the personification of painting [FIGURE 34]. To represent her realistically

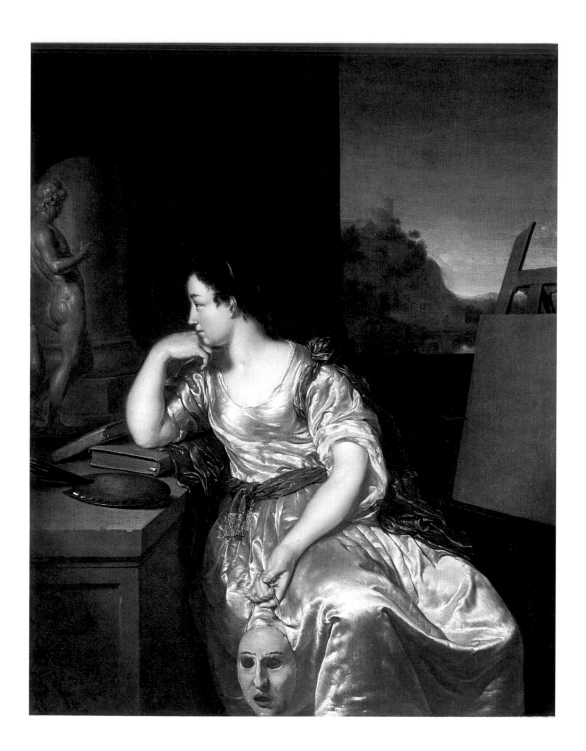

the painter followed the description of this hieroglyphic creature in Cesare Ripa's standard manual of humanist symbolism (mask, heavy dark hair) but omitted the less convenient features (she is supposed to be gagged as a symbol of her meditative silence) and emphasized her melancholic beauty. There are some tools of the painter's craft—an easel, mortar for pigments, bottles of varnish, palette, and brushes—but Pictura is not getting her hands dirty. She leans significantly on a book and fastens her attention on the ideal beauty of the statuette. (Her attitude is enough like that of Steen's girl to suggest that perhaps the latter may also represent Pictura, but there is really nothing to identify her with Pictura beside her rich costume and pose.)

Pictura is a kind of muse invented for the art of painting, which lacked one, since painting had not originally been included in the Seven Liberal Arts and needed a suitable personification. Clio, the muse of history, who is the model for the anonymous painter in Vermeer's famous allegory [FIGURE 4], brings a different kind of distinction to the atelier. She stands for the whole realm of biblical and ancient history, the depiction of which was the highest purpose of the art of painting and the activity that Vermeer's painting celebrates.

Ateliers often contain other symbolic reminders, less striking than Pictura and Clio but loaded nevertheless, that the art of painting is a great and serious business. We easily recognize the symbolic apparatus of Vanitas. Still lifes of this kind were a specialty of Steen's colleagues in Leiden. Candles, smoke, skulls, flowers, books, musical instruments, etc., endlessly combined and recombined, are omnipresent allusions to the lessons taught from every pulpit, Calvinist or Catholic, that life is brief, pleasure is a gift that is potentially dangerous and must be taken in moderation, and everything in human life except piety is vain. The painter's atelier is often equipped with reminders of this kind because it is a place where pleasurable illusions are manufactured, as we saw in the case of the painting by Craesbeeck [FIGURE 26]. In another instance [FIGURE 35] studio props are arranged into a Vanitas still life that includes portraits, a bust, pens, and the same plaster statuette found in Steen's *Drawing Lesson*. Everything is lighted by a candle—the light, as we will see shortly, that was used for the after-hours study of such sculptures, an activity that formed an essential part of the training of artists. Here the candle is liter-

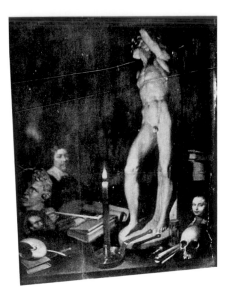

Figure 35
David Bailly (Dutch, 1584–1657). *An Artist's Studio*, circa 1640. Oil on panel(?), dimensions unknown. France, private collection.

ally and figuratively enlightening, but the seventeenth-century spectator knew that it would burn to its end.

The commonest feature in the depiction of ateliers, however, is work and study by young artists-to-be. Assistants are shown in the background performing menial labor, as we saw earlier; less common, but of greater significance for Steen's *Drawing Lesson*, are paintings showing the actual business of instruction by the master and study by the pupils. To this function of the atelier as classroom we now need to turn.

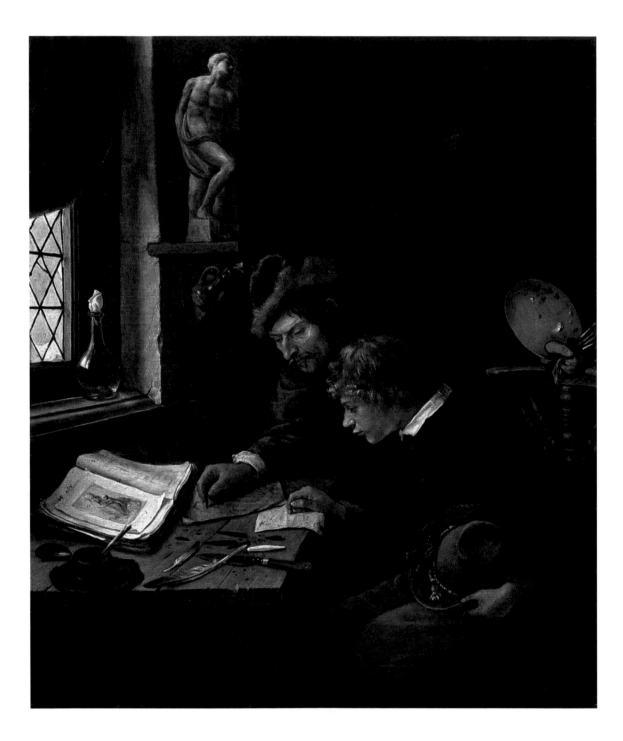

THE TRAINING OF A PAINTER

In the seventeenth century the atelier was the place—the only place—where professional painters were trained. There boys learned their trade in a process of work-study that needs to be understood if we are to appreciate the context of *The Drawing Lesson*. Twentieth-century ideas of art education will not be of much help, for these are based on modern assumptions: for instance, that the painter's job is more to communicate his personal subjective states than to transmit traditional values, or that the artist ought to be independent, choosing a financially risky life on the fringe of society if necessary. These would have seemed strange ideas to Steen and his contemporaries. In our time painting has become primarily an intellectual or spiritual activity that is no longer constrained by the labor and discipline of imitating nature or expected to embody learning. Painting in the seventeenth century, in contrast, was practiced entirely within the social and economic boundaries of the system that supported it.

Painting remained a handicraft in Steen's time, as it had been in the Middle Ages and would remain for more than a century after his death. You could sell your work in a given city only as a member of the local painters' guild, which thus had a legal monopoly. The guild regulated the training of students, sometimes prescribing the length of training and subsequent apprenticeship under a master painter, limiting the number of pupils a master could take each year, and stipulating that the pupils' work would become the property of the master. It was on-the-job training that students received, in other words, not an education in the modern sense. Training and production were linked: the master gained help and thus increased his salable output; the pupil gained knowledge of the profession in the only way possible and then qualified for membership in the guild.

Merged with this medieval method of training in the workshop was another, more recent activity that carried the seeds of modern art education: the study of the fundamental elements of art—geometry, perspective, anatomy,

Figure 36
Jan Steen. *A Master Correcting a Pupil's Drawing*, circa 1665–70. Oil on panel, 24 × 20 cm (9½ × 7⅞ in.). Maastricht, private collection.

43

and so on—and of the best examples of the ancient and modern past. Drawing was the key to this study. The master was expected to be the young artist's guide to this higher realm of learning.

Why send your child to be trained as a painter in the first place? He might be conspicuously talented. Or he might be merely promising as an artist but hopelessly unpromising in other areas. You or a relative might be a painter yourself and thus able to give the boy free training, expecting that he would remain in the shop and carry on the family business. You might hope to take a step up the social ladder (or a step back up, if bad times had brought you lower) by having a painter in the family, since the rungs occupied by painters spanned the broad economic and social middle, and you could climb higher if your artist son served a rich and powerful clientele. Summarizing "what fruits an artist can expect in exchange for his labor," Samuel van Hoogstraeten in 1678 packaged in a couplet the incentives given by Seneca:

> Three passions stoke the fire
> of him who th'arts would learn:
> It's love, profit, and honor
> that cause his heart to burn.

Profit was a motive, but it was no sure thing. In Steen's time the Dutch Republic had experienced the largest art boom in history, and exactly because the market for paintings had been broad and sales robust, the profession had attracted crowds of competent, prolific people. Commissions by city officials and private organizations for paintings of commemorative subjects or group portraits held out shining incentives for profit and honor, but these actually came along too infrequently to sustain many careers. The open market was full of landscapes, genre paintings, still lifes, and other pictures that sold cheaply if they sold at all. When the economy took a dip, as it did during the naval war with England from 1652 to 1654 and again from 1665 to 1667, it was luxury goods that people economized on first, and art sales dropped. A great many talented painters led an uncertain life as a result, and some of them, like Jan Steen, resorted to second jobs in an attempt to secure a steady income. Love of art, a lack of other prospects, or perhaps just blind hope kept them in the profession.

How to know that your child has talent? Observe whether he makes drawings of his dolls and puppets, say seventeenth-century writers. In about 1525 the schoolboy Johannes made pen drawings of an ensign in his copy of *Aesop's Fables* [FIGURE 37]—just what parents were supposed to look for. Since schoolchildren were usually not permitted to draw by themselves in class, yet the gifted child would draw anyway, this disobedience would be another sign of his inclination to art, according to van Mander. That inclination had two components, spirit (*geest, ingenio*), whose symptoms were a quick wit and inventiveness, and desire (*lust, inclinatio*), which betrays itself by an irresistible urge to master the skills. Talent alone was not enough; talent would have to be reined in by discipline and harnessed to difficult tasks.

The would-be art student might or might not have had considerable schooling before he came to the workshop. This seems to have varied a great deal. A few, like Steen and Rembrandt, not only went to Latin school but actually matriculated in a university (though, as we have seen, this was evidently the end of formal education rather than the beginning of a new phase). The age

at which a boy was sent to a master painter was normally somewhere between twelve and sixteen. The same was true for the other handicrafts involving much manual training; boys destined for less prestigious trades like baking and barrel-making started work even younger.

The Business of Training

"Get a good master," says van Mander. Having decided that their boy had talent, the parents needed to choose a master painter and decide what sort of arrangements to make with him. The master ought to set a good example for his pupils, says van Mander, unsurprisingly. A track record for producing qualified journeymen and guild members was obviously important. Van Mander says the master should have good works of art in the workshop, meaning a collection of study material such as books, prints, drawings, plaster casts, and the like. Van Mander and other writers went to some rhetorical lengths to glorify the role of the master painter, likening him to a father, a Cheiron (the wise centaur who taught the Greek heroes), a wet nurse, a bringer of light, a star, a guide, and so on.

Bringer of light or not, the master was a businessman, and his relation to the pupil was governed by contract. Because the student was usually a minor, his parents made these arrangements for him. He was bound for a term of years, normally five to seven for a beginner, fewer for those who already had training elsewhere. Guilds generally required not less than two or three years' training. Of the considerably longer period that was common, the first three or four years were spent in actual training as *leerling* (or *leerjongen*), pupil; and the last few years were spent working for the master as *gezel*, journeyman. Parents might contract to have the boy spend his whole training and apprenticeship under one master, or, by separate contracts, with several in succession. The fees paid by the parents were substantial but variable, subject to negotiation depending on several factors: the reputation of the master; the length of the contract (the longer the cheaper); whether the master provided housing, food, clothing, and materials; and whether the pupil's work became the master's property, or whether instead the pupil was free to sell it himself. The costs thus reflected a businesslike assessment of who was getting what from the deal. In Jan Steen's

time the most prestigious teachers—Rembrandt in Amsterdam, Gerard Dou in Leiden, and Gerard van Honthorst in The Hague and Utrecht—received one hundred guilders from each pupil per year without bed and board, and since many of their students were amateurs (about which more later), they were permitted more pupils—several dozen—than the guilds normally allowed. Teaching could be a lucrative sideline for painters, to say the least.

The surviving contracts are not very specific about what the pupil got for his fee, no doubt because this was traditional and too well understood to need spelling out. Generally the master was to "provide instruction, to the best of his ability and as he himself practices it, in the art of painting and all that goes with it," or words to that effect. "Without concealing anything" is sometimes added. Most pupils seem to have expected to learn the master's own specialty—portraits, history, landscape, or some other—trade secrets and all. The point was eventually to make the pupil independent, "able at the end of these seven years to earn his living honestly," as one contract puts it.

For his part, the pupil agreed to be faithful, to be obedient, to be diligent in work and study, and to strive for the "profit and advantage" of his master. He was obliged to keep regular hours, which made for a long day, dawn to dusk at a minimum. Pupils who boarded with the master were like paying family members, the master serving *in loco parentis* and the pupil eating at the family table (although one contract stipulates that the boy doesn't get to eat with the master until the last two years of the six-year period!).

The pupils' financial circumstances differed widely, and so did the contracts. A poor boy might have a long-term contract as a *dienaar* (servant) requiring menial work in the studio and providing for training on the side; for this he would be paid. For a boy of middling means the contract might call for training with work on the side; this was more expensive. Or else the contract could specify training only, perhaps because the parents of the pupil were well off or because the pupil was an amateur, or both, or because he was already advanced by virtue of training elsewhere. The fee for this kind of tutorial arrangement was the highest. The longer the contract, the more work the pupil would be able to perform for the master, particularly in the later years when he was more competent and productive.

Training in the atelier did not follow a curriculum in the modern sense of a pre-scribed course of study. Instead, training had a traditional sequence of phases, varying in emphasis from master to master and changing somewhat during the course of the seventeenth century under the influence of Italian and French aca-demic ideals. The core of a painter's training at any time and in any country in Europe, however, was drawing.

First came menial jobs. *Dienaars* and most other pupils worked at the basic tasks of the master painter's small manufacturing business, tasks that are familiar from van Mander's descriptions, contracts, and depictions of work-shops: grinding pigment for paint, stretching and priming canvases and pre-paring wood panels, caring for the brushes, laying out colors on the palettes, cleaning up, and looking after the equipment of the shop [FIGURE 23]. This is a far cry from the activities of the twentieth-century art school, where materials are bought at an artists' supply shop and where the craft of making objects is subordinate to the ideas. All this practical lore was essential to absorb, however: it belonged to the master's *handelinge*, his entire way of working, which was exactly what you came to learn. How you learned it was partly a financial deci-sion, as we just saw: you either paid for your instruction with your labor and learned by doing, or paid extra to be an observer of the labor. Most pupils or their parents evidently chose the former.

During and after the dirty work came drawing. "If you want to ascend to the art of Painting, you have to climb up by Drawing," wrote Hoog-straeten. Without drawing, "painting is not only defective, it is dead and abso-lutely nothing." It was taken for granted that drawing was an indispensable tool in the manual work of making pictures. It was also a means of apprehending the natural world and assimilating the art of the past—an intellectual as well as manual activity. Drawing functioned for young artists like the keyboard for a music student: it was the instrument with which you came to grips with the compositions of the masters of the past and tried out your own. Drawing was a counterpart to performing the more practical tasks of art (*oefeninge*, practice) that occupied you at the same time. Drawing was a part of *studie*, the essen-

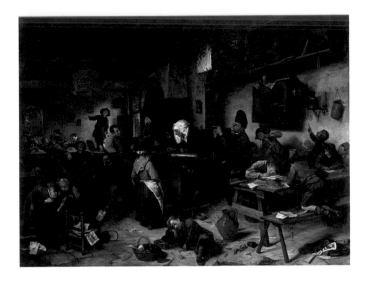

Figure 38
Jan Steen. *School*, circa
1674–78. Oil on canvas,
89 × 109 cm (35⅛ ×
42⅞ in.). Edinburgh,
the Earl of Sutherland,
on loan to the National
Gallery of Scotland
(NG 2421).

tially intellectual work you were expected to do with the master's help and on your own after hours. Well-to-do nonprofessionals could pursue this *studie* as well (see below). The master did more than provide the study material and look over your shoulder making suggestions, he made corrections on your drawings. "I advise masters, when they look over pupils' drawings, to correct them by sketching right on the drawings," Hoogstraeten wrote. "This provides unusually good experience and has helped many people greatly in the art of arrangement." Steen's painter is doing just this in *The Drawing Lesson*. As a young man, Hoogstraeten had observed this process in Rembrandt's large studio, and Rembrandt's bold corrections on drawings by other pupils can still be seen.

This is the moment to point out that the teacher-pupil relationship, which is portrayed in an idealized way in *The Drawing Lesson*, could go very wrong in Steen's schoolroom paintings. Like his quack doctors, Steen's schoolmasters are vaguely theatrical figures of fun, dressed in a queer assortment of old clothes and ridiculously incompetent. They are either capable only of cruel discipline or else so inattentive that all hell breaks out in the classroom [FIGURE 38]. What Steen shows in *The Drawing Lesson* is a Cambridge tutorial by comparison.

As a beginner you copied prints and drawings. In these models a skilled artist had already reduced a three-dimensional subject to a flat surface, and it was one of the pupil's tasks to understand how this was done. "Young people are generally set to copying eyes, ears, noses, mouths, ears, and various faces, from all sorts of prints," says Hoogstraeten. The handiest sources for these body parts were drawing books, collections of prints ready-made for the study of the basic elements of the human figure, not just its parts but also its proportions, anatomy, and various physical types. The "various faces" Hoogstraeten mentions were of interest for their structure and later for what they could teach about expression. To see how useful a drawing book could be, look at the flying infants in Frederik Bloemaert's book [FIGURE 39]: the four different views of the same statue provide not only more anatomical information than a single view, but also a demonstration of how to foreshorten the figure when it is seen from various angles. Bloemaert's model was undoubtedly a plaster cast very like the one that hangs in the studio in *The Drawing Lesson* [FIGURE 1 *and* FOLDOUT].

Entire prints might be copied for their overall composition or else parts might be excerpted from them, "nice faces, beautiful well-made nudes or natural movements, statues, nice drapery and strange appurtenances: in others, lovely buildings, views, and landscapes, or beautiful horses, dogs, or unusual animals." As to the most profitable subject for these drawing exercises, the prescription of seventeenth-century writers and the actual practice of masters were in accord: the human body. They shared the Italian belief that if you could draw the human form, you could draw anything.

You should copy very good drawings early in your training so that you learn a good manner of working, says Houbraken. In another painting by Steen [FIGURE 36] a boy has been copying a Raphaelesque drawing of the Madonna and Child, the loose sheet in the open book in front of him, and watches while the master—a painter, of course, holding a conspicuous palette—corrects the drawing. The clutter of various colored chalks, inkpot, quills, and knife for cutting pens from the quills make up a little still life of draftsman's tools.

"When you have [copied drawings], and when your eye is somewhat clearer, it will not do you any harm to copy many-colored paintings in drawings

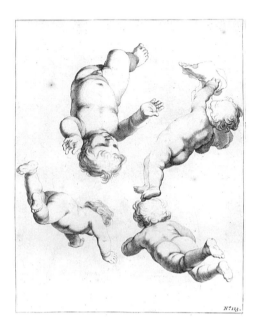

Figure 39
Frederik Bloemaert
(Dutch, after 1610–1669)
after Abraham Bloemaert
(Dutch, 1564–1651).
Putti, before 1650.
Engraving in *Konstrijk
Tekenboek* (Amsterdam,
1740), no. 113. 38.1 ×
25.4 cm (15 × 10 in.).
Amsterdam, Rijksmu-
seum-Stichting (54-A-7).

of a single color," according to Houbraken. With the painting in front of him, the pupil sketched the whole composition on a single sheet, then copied the parts separately. Boys making copies of paintings must have been a common sight in workshops, but they are rarely represented doing this [FIGURE 40].

In the next stage of training, two-dimensional study material was exchanged for three-dimensional: first plaster casts, then living models. The plaster casts were essential study material. "It will be absolutely necessary," wrote Willem Goeree, "that one make drawings after copies in the round and plaster casts of good masters; such as one can come across very easily, some being very common and familiar; many of these can be bought for a modest sum and used to great advantage in the practice of art." Paintings of Dutch studios reveal something of the range of these collections of casts. They cover the standard Greek and Roman examples such as the *Spinario* and Farnese *Hercules* and Medici *Venus*, as well as the work of modern sculptors, not just Michelangelo and Giambologna but others like Leonhard Kern. Pupils studied them in the diffuse light of day and also by candlelight, by which their musculature is more strongly defined [FIGURE 43].

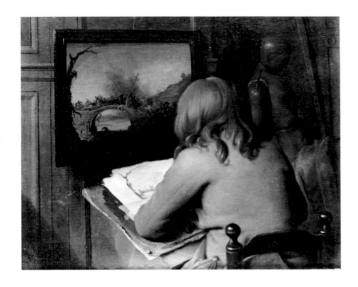

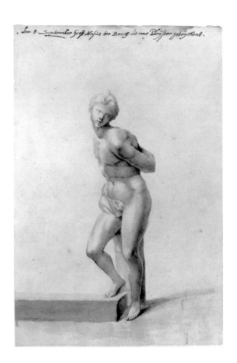

There must have been vast numbers of drawings made by students in
the seventeenth century, but almost none survive. Where have they all gone?
The sensible suggestion has been made that to save the cost of paper, students
used erasable tablets for most of their work. (If so, the pupil's drawing on expen-
sive blue paper in Steen's painting would represent a purposely idealized situa-
tion.) Among the few surviving drawings by pupils is a copy by the very young
Mozes ter Borch of a statuette made from one of Michelangelo's marble *Cap-
tive*s [FIGURE 41], the same statue, incidentally, as one in another studio paint-
ing by Steen [FIGURE 36].

Some casts of arms, legs, heads, and feet used as teaching aids were
not actually sculpture but were made from life, like the "human limbs in plas-
ter to be drawn from life and on a larger scale" in his teacher's shop mentioned
by Constantijn Huygens, or the foot and one of the heads in Steen's atelier.
Whether from life or from sculpture, most casts represented the human nude,
"in which everything in the whole world is included in brief," according to

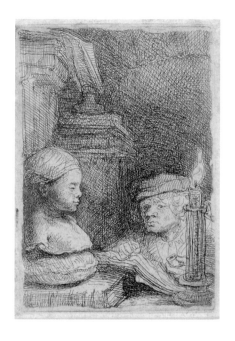

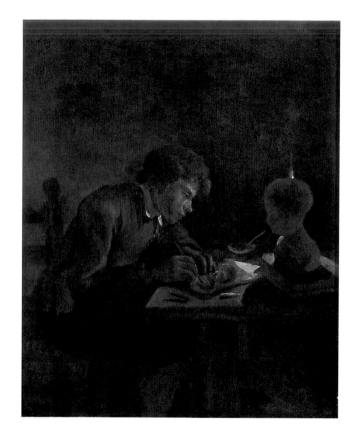

Goeree. Inventories of their property reveal that the most successful teachers had great quantities of casts and prints. These sculptures, added to the paintings available in reproductive prints, constituted a sort of *musée imaginaire* for young artists.

 This aspect of *studie* is what we see most often in pictures like Steen's and why we are justified in calling artists' workplaces *studios*, not merely workshops. The struggle for mastery of the human figure—the core of artistic development—became a subject in itself. Rembrandt's tiny etching of a man drawing from a cast is the most dramatically composed of these [FIGURE 42]; it was evidently the model for Steen's little panel of a boy drawing [FIGURE 43]. Small boys hard at work at their great task, solitary, sometimes dwarfed by the adult scale of the works they aspire to rival, are one of the most sympathetic

Figure 42
Rembrandt Harmensz. van Rijn (Dutch, 1606–1669). *Man Drawing from a Cast*, 1630s. Etching, plate: 9.4 × 6.5 cm (3¾ × 2½ in.). Boston, Museum of Fine Arts, Harvey D. Parker Collection (P526).

Figure 43
Jan Steen. *Pupil Drawing by Candlelight*, circa 1665. Oil on panel, 23.5 × 20.5 cm (9¼ × 8⅛ in.). Leiden, Stedelijk Museum 'de Lakenhal' (S.406).

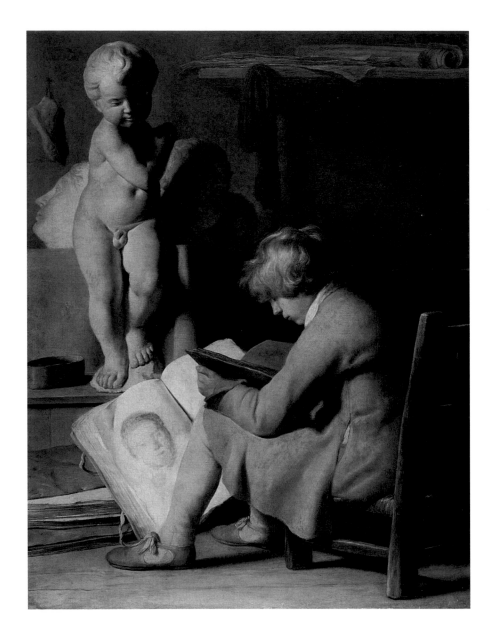

Figure 44
Wallerand Vaillant.
Young Draftsman, circa
1666. Oil on canvas,
129 × 100 cm (50¾ ×
39⅜ in.). Paris, Musée
du Louvre.

subjects in all of Dutch art [FIGURE 44], no doubt because they were grounded in the painters' own experience. The subject continued to appeal to painters in the next century, most memorably in the work of Chardin [FIGURE 45].

 Next came the live model, which you drew in the studio in the company of others or by yourself. Groups of artists pooling the use of a model, which were already common in Italy and France, would eventually become the heart of academic instruction in Holland, but until the middle of the seventeenth century these seem to have been relatively infrequent. In the 1640s and 1650s associations of professionals and amateurs that came together to draw the nude (*collegias*), such as we see in the engraving by van de Passe [FIGURE 46], are encountered more frequently, existing alongside and complementing the basic professional teaching of the studio.

 If you had no live model, you could use a lay-figure or mannequin (*ledepop*), a jointed puppet like a small department-store dummy supported by a stand, which you could pose and clothe any way you pleased. One of these can be seen on the floor of Ostade's workshop [FIGURE 3] and another next to Vaillant's student [FIGURE 40]. In 1635, the elder Gerard ter Borch wrote to his

Figure 45
Jean-Baptiste Siméon Chardin (French, 1699–1779). *Young Student Drawing*, circa 1737–38. Oil on panel, 19.5 × 17.5 cm (7⅝ × 6⅞ in.). Stockholm, Nationalmuseum (779).

Figure 46
Crispijn van de Passe II (Dutch, circa 1593–1670). *Drawing from a Model*, 1643. Engraving, 30 × 39 cm (11⅞ × 15⅜ in.), in *'t Licht der teken- en schilderkunst* (Amsterdam, 1643). Amsterdam, Rijksmuseum-Stichting (330-B-13).

son Gerard in London, "Dear Child, I send you the mannequin. . . . For a bit of money you can get a stand made there. Use the mannequin and do not let it stand still as it has done here, but draw a lot. . . ."

WOMEN IN THE STUDIO

Painting was a trade taught by men to boys. Yet in *The Drawing Lesson* Steen included a girl in the studio and even let her upstage the males, painting her at full length and giving her a strikingly beautiful costume that is the only area of rich color in the picture. Who is the girl, and what is the point of all this? We have already considered whether she might be allegorical—Pictura minus her customary attributes—but found nothing to support this except her prominence. Let us consider how women artists are portrayed and what is known about their training.

There were professional women artists in the Netherlands during the seventeenth century whose work can be identified today, but they were a tiny minority of the artist population. The profession of master painter was open to them in theory through membership in the guilds; in practice, however, there were not many girls whose talent coincided with a willingness on the part of their parents to sponsor their training. Among the few women enrolled as guild members was the relatively well-known genre painter Judith Leyster, who entered the Haarlem guild in 1622. Several dozen other women are mentioned as painters in biographies or named as the authors of certain works listed in inventories. Not all were professionals; some were trained amateurs. In the few instances in which we have portraits of these women painters, they are shown in a conventional way, with individualized features, and while they may hold palette and brushes and sometimes have an easel with a painting on it, they never play a part in the sort of studio scenes we have been examining.

On the other hand, in a painting by Gabriel Metsu, Steen's contemporary in Leiden of the 1650s, a young women is shown at a table with the familiar props of a plaster cast and a print, absorbed in practicing drawing [FIGURE 47]. Is she a female counterpart of the boy who burns midnight oil in Steen's little painting [FIGURE 43], preparing assiduously for a professional

Figure 47
Gabriel Metsu (Dutch, 1629–1667). *Young Lady Drawing*, circa 1660. Oil on panel, 33.7 × 28.7 cm (13¼ × 11¼ in.). London, National Gallery (5225).

56

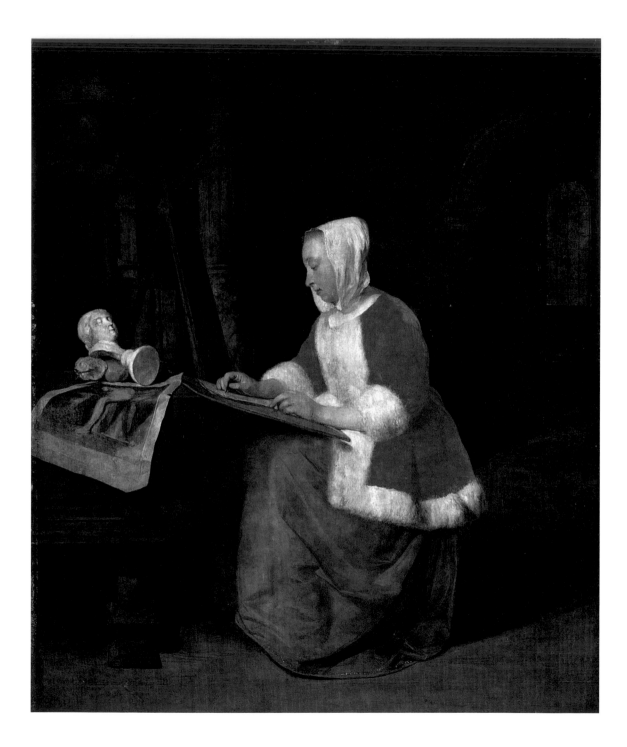

career? Her costume makes that very improbable. The jacket with sumptuous ermine trim and satin skirt are not working clothes for the painter's atelier. Is she Pictura? She has none of the attributes. It seems more likely that her clothes and her activity identify her as one of the many women and girls from the upper levels of Dutch society who learned to draw and sometimes paint as a polite accomplishment, not as a trade. Art, poetry, and music helped to make the unmarried girl attractive to suitors and to make the married woman more of an ornament of the household. Metsu's picture is an image of an ideal of female cultivation that still had three hundred years of life left in it. The painting also advertises art as a genteel activity suitable for the most privileged.

Some years after painting *The Drawing Lesson*, Steen returned to the subject and painted another version [FIGURE 48], rearranging the contents in a way that reflects back on the earlier picture and makes his intentions clearer. A splendidly dressed girl is shown looking on as the master corrects a drawing by the boy pupil. The boy wears a linen collar and jacket with slashed sleeves, a more expensive costume that appears to identify him as a child of well-to-do parents who is taking instruction. The only clue that we are in an artist's studio at all is the big landscape painting leaning against the wall in the background, to which an older assistant appears to be applying retouches; the room has none of the usual studio litter of plaster casts, artists' materials, etc. On a table richly draped with an oriental carpet are a vase of flowers and a recorder, which may be subjects for the pupils to study or, more likely, allusions to cultivated pleasures. This appears to be a painting of a master teaching young people of the upper classes, not training apprentices under contract to him.

The flowers on the table are a reminder that several professional women painters were flower specialists (Rachel Ruysch and Maria van Oosterwijk, for instance). They anticipate the interesting case of the eighteenth-century amateur flower painter Catherina Backer, whose rich family encouraged her painting as a way to drive away fits of melancholy that were aggravated by her isolation in a large house in Leiden: "Read something you enjoy for variety's sake," wrote her father, "then go back to painting, but not for too long, or else find another distraction."

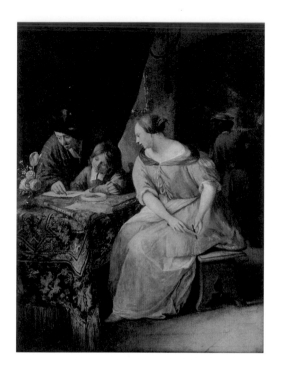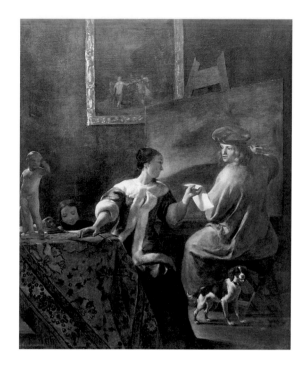

There are only a handful of seventeenth-century paintings of women in studios, all painted in a thirty-year period. The vogue was evidently brief. One final example is more interesting than beautiful, a painting once attributed to Jacob Ochtervelt [FIGURE 49] in which another richly dressed young woman plays the leading role. Together with a young boy she has been drawing a plaster cast; the master opposite her has been painting at the easel, and she interrupts him to present her drawing. There is an air of easy familiarity in her way of claiming his attention. She seems to be neither muse, nor allegory, nor amorous interest for the painter, but rather a well-born habituée, a kind of attribute of the studio who attests to its refinement and to the social status of the profession.

Figure 48
Jan Steen. *A Painter with Two Pupils*, circa 1670. Oil on panel, 41.6 × 31.1 cm (16⅜ × 12¼ in.). Cambridge, Fitzwilliam Museum (0078).

Figure 49
Anonymous Dutch painter (formerly attributed to Jacob Ochtervelt). *Artist with a Woman Student*, circa 1665. Oil on canvas, 72.5 × 59 cm (28½ × 23¼ in.). Bonn, Rheinisches Landesmuseum (37.50).

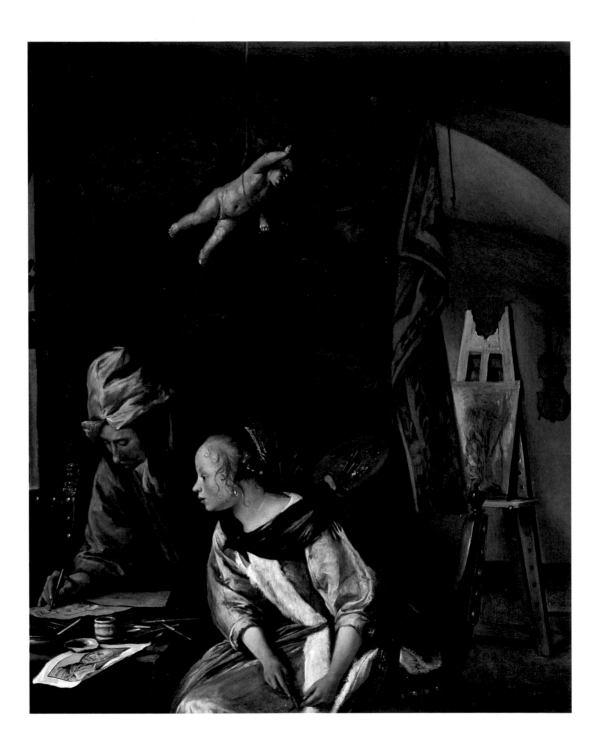

ANOTHER LOOK AROUND

Steen's life and the subject matter of *The Drawing Lesson* have taken us far afield among Steen's other works, among paintings of ateliers from the Renaissance on, among pictures of artists being taught their trade. It is time to return to the painting for a more leisurely look. In the light of what we have seen of its context, let us explore the significance that Steen may have meant it to have.

THE SETTING

Steen's painter has grand quarters, a long room surmounted by a high, groin-vaulted ceiling. It is not the tidy, rational, rectangular box of de Hooch and the Delft painters [FIGURE 4], nor is it the picturesquely decrepit room of Ostade's landscape painter [FIGURE 3]. The vaulting recalls the vaguely medieval imaginary studios painted in Leiden by Gerard Dou and his followers and actually resembles the somewhat less imposing studios painted by van Mieris [FIGURES 30, 31]. It has a domestic air but is obviously not part of an ordinary Dutch house. It is a room in an old building whose spaciousness attests to the artist's worldly success and reflects well on his standing and that of his profession. Dividing the studio is a tapestry that hangs from rings on the ceiling. This cloth hanging is an expedient that appears in other atelier paintings, such as Vermeer's [FIGURE 4]. It would give some privacy on both sides, and for the painter working at the easel beyond it would cut down on bothersome reflections from the back window and the rest of the room.

THE MASTER

The master painter holds a palette and brushes, which do not merely identify his trade but connect him to the easel behind the tapestry curtain. On the easel is a wood panel representing several figures in a landscape. The subject cannot

Figure 50
Jan Steen. *The Drawing Lesson* [detail].

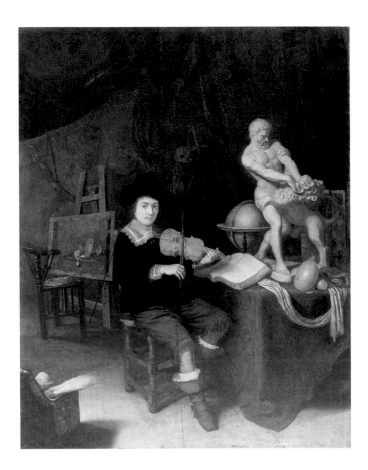

Figure 51
Joris van Swieten (Dutch,
?–1661). *A Painter
Playing the Violin*, circa
1645–50. Oil on panel,
47.5 × 63 cm (18¾ ×
24¾ in.). Present
location unknown.

be made out, but it may be the Good Samaritan and the wounded Israelite or else the Holy Family in a *Flight Into Egypt*. What matters about this little painting is not its exact subject but the fact that it shows figures who are not part of a scene of everyday life; it is instead a history painting. This is meant unmistakably as a sign that the artist belongs to the topmost category of painters, those whose work was the most difficult, required the most training, and secured the richest rewards: the *peintre d'histoire*, as he was known in France, a painter like those in Bosse's engraving [FIGURE 25]. That the Dutch recognized this hierarchy of categories is made plain by such writers as Hoogstraeten, who in 1678 identified three grades of painting: in the lowest was still life, including flower pieces, kitchen scenes, and such; in the middle category he included arcadian

subjects and several other types that we would now call "genre"; and in the top bracket were historical, mythological, and religious subjects.

On the wall behind the easel hangs a viol, the sort of musical instrument that is often seen in pictures of artists' studios. For centuries instruments had been conventionally associated with inspiration. Leonardo da Vinci prescribed working while listening to music. Dutch painters sometimes show artists actually making music at the easel [FIGURE 51]. Houbraken tells how Gerard Lairesse, the leading artist of his day, would sit at his easel and play the violin for inspiration. Stringed instruments could also allude to harmony and proportion, and of course, they were a reminder to the spectator that the painter is a cultivated man whose virtuosity extends beyond the specialized métier he happens to practice for a living.

Steen's master painter has long hair and a drooping moustache, which to our eyes may give him a raffish and even slightly comic aspect, but comedy was not intended—the style was very much in fashion for painters of the 1660s. His splendid costume would hardly have been practical for working in the studio and is clearly worn for show. He has a soft hat turned up to show a lining of orange-gold silk. And he wears a robe that is no studio smock but actually a kimono, a Japanese import that was coming into fashion among those who could afford one. (What was an expensive novelty in the 1650s and 1660s soon became commonplace, however. By the early eighteenth century a French visitor to Holland sarcastically remarked that there must be an epidemic, since so many people were walking around in their bathrobes!)

TEACHING MATERIALS

The master is using a quill pen to correct a drawing on blue Venetian paper. The drawing cannot be deciphered, but it ought to represent the statue on the table (about which more in a moment). Which of the two pupils made the drawing is not clear, but the boy has a nearly straight-on view of the statue; comparison with the closely related painting in Cambridge in which it is obviously the boy's drawing that the master corrects [FIGURE 48] suggests that the same is true here. On the table is equipment for drawing: another quill pen sticking out of a cov-

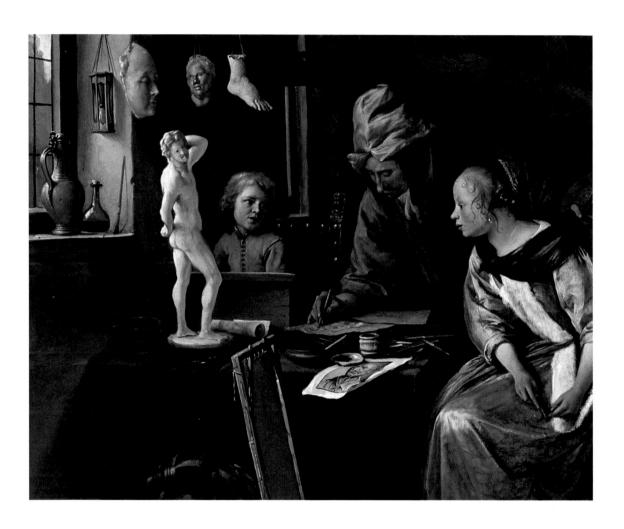

Figure 52
Jan Steen. *The Drawing
Lesson* [detail].

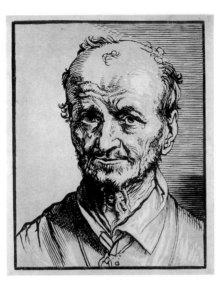

Figure 53
Jan Lievens (Dutch, 1607–1674). *Bust of a Man*, circa 1640–55. Chiaroscuro woodcut, 17.5 × 13.3 cm (6 ⅞ × 5 ¼ in.) and 18.7 × 14.6 cm (7 ¹⁵⁄₁₆ × 5 ¾ in.) [two blocks]. New York, The Metropolitan Museum of Art, Harris Brisbane Dick Fund, 1925 (25.2.61).

ered container (to store liquid that would evaporate, probably used to dilute ink for use as wash), a shell and brushes for the wash, and sticks of black and white chalk (but no red, which would normally be there as well).

There are a few bits of painting equipment, too, some of it practical and some symbolic. A stoppered glass flask on the windowsill probably contains picture-varnish that is being exposed to the sun to clarify it. Next to it is a brush, negligently left standing on its bristles. A covered stoneware bottle very likely contained water that, mixed with pigment, made the wash for shadows in drawings. Above these hangs an hourglass, the most familiar of symbols for passing time and thus for the brevity of life. It looks as though it is actually running.

STUDY MATERIAL

A print sticks out dramatically from the table in our direction [FIGURE 52]. It is easily recognized as a colored woodcut by the Dutch painter Jan Lievens that represents one of the most complex and memorable faces in all of Dutch art [FIGURE 53]. Steen chose it, no doubt, because it would be a challenge for any copyist and also an allusion to Expression, one of the elements of art that had to

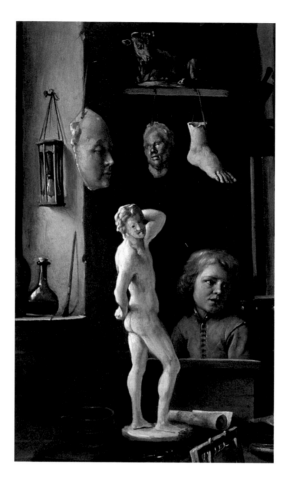

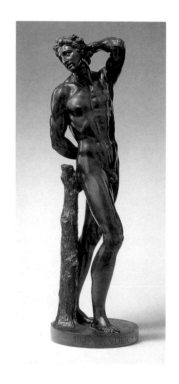

Figure 54
Jan Steen. *The Drawing Lesson* [detail].

Figure 55
Alessandro Vittoria (Italian, 1525–1608). *Saint Sebastian*, 1566. Bronze, height: 54 cm (21 in.). New York, The Metropolitan Museum of Art, Samuel D. Lee Fund, 1940 (40.24).

be mastered, according to all writers on art theory. In Karel van Mander's didactic poem addressed to young artists there is a chapter on the *effecten*, the depiction of expression, which he calls "the soul of Art," and Hoogstraeten, as we saw earlier, mentions the practice of copying "various faces" from prints, which pupils were expected to do in the course of their tutelage.

On the table is a plaster cast of one of the more popular sculptures during Steen's time, a small version of the *Saint Sebastian* by the Venetian Alessandro Vittoria [FIGURE 54], a work of the 1560s that appears in a number of other Dutch atelier scenes [FIGURE 35]. Here it is placed so that raking light plays over it for the benefit of the pupils. In the language of van Mander, they

are learning *proporties* and *attitude* from the figure. There is an allusion to Pro-portion in the pair of dividers, which are used to take measurements, at the base of the statue. Like Michelangelo's *Captive*s [FIGURE 41], Vittoria's *Saint Sebastian* must have presented a particular challenge for copyists to understand and render a complex pose and to depict the resulting muscular tensions.

　　Hanging high is a plaster putto [FIGURE 56], an angel or cupid of a familiar type that I have not been able to identify. It resembles the chubby infants of the Flemish sculptors Duquesnoy and Quellinus as well as the ones in Bloemaert's drawing book [FIGURE 39], and it appears in another studio painting by van Mieris [FIGURE 31]. A suspended putto was useful for pupils to study and also handy for the master in case a painting called for *amorini* or angels, as it did now and again for Jan Steen. Rembrandt made a drawing for a *Holy Family* that not only shows just such a hanging angel but also the armature and cord from which he had suspended it [FIGURE 57]. Might Steen have intended the dangling plaster infant as an *amorino* who reinforces something erotic going on down below, the awakening of sexual feeling in the girl and boy? This argument has been made by a distinguished scholar, but, I think, not convincingly. The *amor-*

Figure 56
Jan Steen. *The Drawing Lesson* [detail].

Figure 57
Rembrandt Harmensz. van Rijn. *The Holy Family*, circa 1645. Pen and wash, 18 × 24 cm (7⅛ × 9½ in.). Bayonne, Musée Bonnat (Photo: Doucet/© Arch. Phot. Paris/S.P.A.D.E.M.).

Figure 58
Adriaen van de Velde
(Dutch, 1636–1672).
Cow, 1659. Painted terra-
cotta, 13.2 × 34.5 cm
(5¼ × 13⅝ in.), base:
11 × 36.3 cm (4¾ ×
14¼ in.) Paris, Musée
du Louvre (RF 1161).

Opposite:
Figure 59
Guercino (Giovanni
Francesco Barbieri).
*Saint Luke Displaying a
Painting of the Virgin
and Child*, 1652. Oil on
canvas, 221 × 181 cm
(87 × 71¼ in.). Kansas
City, The Nelson-Atkins
Museum of Art.

ino may suggest instead the noblest of Hoogstraeten's three motives for pursuing art as a career—love.

Three more plaster casts hang at the left. The one in the middle looks like the face of a Roman satyr, but from which sculpture it was made is not known. On either side are a face and a foot that seem to have been cast from living subjects rather than sculptures (a complete foot in the round is impossible to cast from most statues, which stand on bases). Such casts appear to have been standard equipment in studios: Rembrandt's inventory of 1656 listed "eight pieces of plaster work, cast from life."

Seeming to peer down from the shelf on the action below is a statue of a cow or an ox. Statuettes like this existed, and perhaps this is an otherwise unknown variant of the famous terra-cotta cow by Adriaen van de Velde [FIGURE 58]. What it is doing in this particular studio is a more interesting question. It could be study material for pupils to copy, certainly. It could be a learned allusion to instances in which the genius of artists of antiquity was demonstrated by the realistic depiction of cattle—the foreshortened ox of Pausias or the cow of Myron. It is more likely, however, that the statuette alludes to the ox of Saint Luke, the patron saint of artists and protector and namesake of the painters' guild, entry to which was one of the goals of artistic training. Artists could buy casts of the same statuette in Italy, by the way, for it appears in contemporary paintings of Saint Luke by the Bolognese artists Guercino and Benedetto Gennari [FIGURE 59]. The ox brings even more weight to the picture by bearing an allusion to hard work, as we will see shortly.

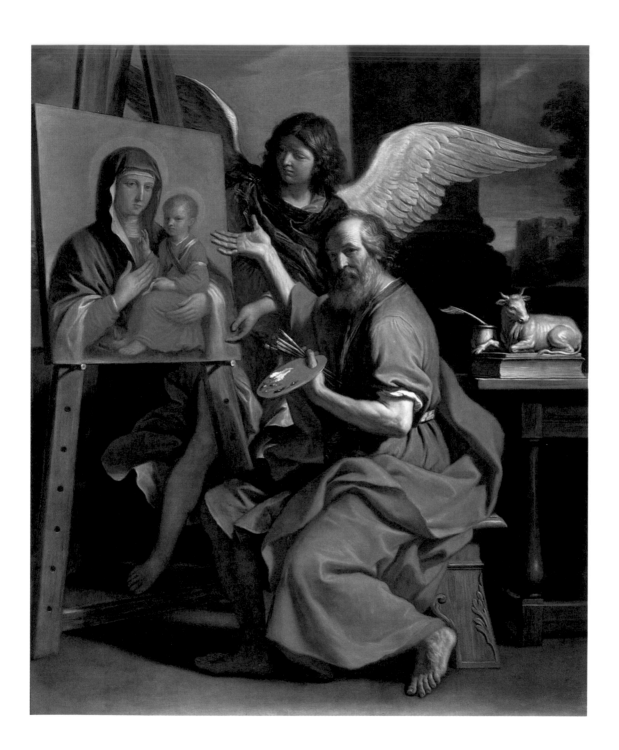

Figure 60
Jan Steen. *The Drawing
Lesson* [detail].

On the floor in the left foreground [FIGURE 60] is a trunk that very
likely contained miscellaneous studio properties, especially costumes for mod-
els in historical scenes. On top is a piece of lustrous plum-colored silk with gold
borders, the sort of oriental cloth used for costumes in Steen's own historical
paintings. (Collections of textiles and costumes were also common in painters'
studios, and Rembrandt's inventory included costumes and a "collection of
antique stuffs of various colors.") No inventory of Steen's property survives, but
we have to imagine that he owned material like this. Under the cloth and bal-
anced on the trunk is a thick album that would have contained more prints and
drawings—the most useful and often most valuable possessions in an artist's
studio. As we saw earlier, prints were important for what they could teach a
pupil about the art of the past. The majority were what we today call "repro-
ductive" prints made from the designs of the great masters, often under their
authorization. For painters at all stages of their careers, whether or not they
ever had the chance to travel to see the original works, these prints were an
introduction to the styles and forms of countless artists, as well as a ready

source of pictorial ideas and solutions to problems of pose, composition, historical costume and decor, and more besides. Inventories of artists' estates usually mention quantities of works of art on paper, which were left, as a rule, to whomever inherited the studio—that is, the person who carried on the business of making and selling pictures and teaching pupils.

PROPS

A canvas leans against the trunk, strongly foreshortened and lighted from the back so as to highlight the frame, corner braces, and laces. This is an unusual rig to a modern eye. In the seventeenth century a canvas was first strung like a trampoline inside a wooden frame and then painted [FIGURE 29]; after it was finished and dry, it was unstrung and nailed over the kind of stretcher that is familiar today.

On the floor in the lower right is a still life that is one of the delights of Steen's picture [FIGURE 60]. Light plays delicately over it, and the various surfaces are painted with particular subtlety. A basket contains a fur muff that evidently belongs to the well-dressed girl. Moving clockwise, there is a bowl with glowing embers and a clay pipe, a flagon of wine, a skull, a wreath of laurel leaves, a book, and a small lute called a cittern. Objects of this kind are found in other pictures of artists' studios and, as we noted before, they are part of the familiar repertory of *vanitas*, reminders that life is short, that excessive pleasure is dangerous, that human achievements are fleeting, and that even fame, symbolized by the wreath, will perish as the former owner of the skull has done.

The fur muff is not simply an allusion to the vanity of earthly luxury. It alludes to one of the five senses, touch, just as the pipe stands for smell, the wine for taste, the book for sight, and the lute for hearing. We have seen that in other studio scenes the five senses may be present in the guise of drinking, smoking, making music, and so on [FIGURE 26]. In making a seductive painting out of these temptations, the painter is both repeating the warning and creating yet another enticement for the senses. Paradoxes like this were grist for the mill of seventeenth-century meditation.

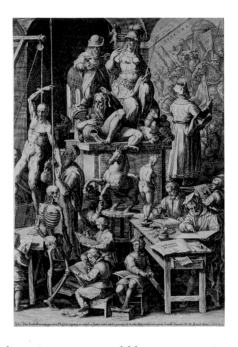

Steen's picture, in short, is a pretty credible representation of an artist's work-place. It surely does not depict an existing studio, much less Steen's own, and there are quite unrealistic elements, such as the fact that the master and girl pupil wear expensive costumes at work. It is nevertheless full of details that can be explained by what we know about artists' practice and by what we can see in other paintings. The question remains, though, why was it painted? Not, I think, just to give the spectator the sheer pleasure of inspecting it, but in addition to say something important about the art of painting.

There are other elements that draw the painting further into the realm of the emblematic and the allegorical. The boy is drawing and the girl is preparing her drawing instrument, either cutting a pen (using a knife to slice a quill to produce a nib) or else sharpening a piece of chalk—it is hard to tell which. These two activities of the pupils, drawing and preparing the instru-ment, are paired in other portrayals of the education of artists. In an engraving

after Stradanus of 1578 representing an ideal art academy [FIGURE 61], boys are shown drawing and sharpening a pen or chalk. They are literally and figuratively at the bottom of a great pyramid of artistic activity. Steen's pupils are not merely drawing, they are being taught to draw, and here a parallel can be found close to home in the work of Gerard Dou, the most successful Leiden painter of the preceding generation: the three-part painting entitled *The Lying-in Room* (*De Kraamkamer*), which represents a mother with a baby in a cradle in the central panel. (It is now lost and we have only a copy, but Steen could have known the original.) Its peculiar format as an altarpiece-like triptych suggests that Dou had ideas that were more elevated than usual to put across, and indeed he did. According to Houbraken, the outside wings of Dou's painting represented the Liberal Arts. Inside [FIGURE 62], flanking the middle panel that shows the mother and child, is a left wing that portrays a lesson being given at a table, and a right wing showing a man cutting a pen. The ensemble has been explained in terms that an educated seventeenth-century spectator would have understood: it illustrates the proposition that three things are necessary for mastery of the Liberal

Figure 62
Gerard Dou (Dutch, 1613–1675). *Nature, Teaching and Practice* (copy by Willem Joseph Laquy), original circa 1650–60. Center section: oil on canvas, 83 × 70 cm (32⅝ × 27½ in.), sides: oil on panel, 80 × 36 cm (31½ × 14⅛ in.). Amsterdam, Rijksmuseum (A 2320).

Arts, natural gifts (Natura), instruction (Diciplina), and practice (Exercitatio). This formula came down from Aristotle through a string of later authors (Diogenes Laertius, Cicero, Erasmus) to recent Dutch editions of Plutarch, so it must have been known to Latin school students like Steen and may already have become a cliché in artists' studios. In Dou's triptych the mother supplies the natural gifts (genetic, we would call them); instruction is embodied by the school group at the left; and practice is symbolized by the man who cuts his pen. In Steen's *Drawing Lesson* we are missing Natura, natural gifts, which does not seem to figure in the program, but Diciplina and Exercitatio are here in the conventional forms of teaching and sharpening the instrument. Exercitatio, practice, is also present in the guise of the ox on the shelf, an allusion not only to Luke, protector and virtuous role-model for the painters' guild, but also to the quality of industriousness that the aspiring artist needs. (That the same object has several different senses at the same time is common in Dutch paintings of this period, just as multiple meanings for words are common in seventeenth-century poetry.)

Another allegorical print of the late sixteenth century will help to make the point about the ox [FIGURE 63]. It shows Mercury, messenger of the gods, leading a young artist to be crowned by Minerva, protectress of the arts: the boy is graduating, so to speak, thanks to study (Diciplina), symbolized by the book next to him, and thanks to industry, symbolized by the oxskin that he wears. Just as Hercules is conventionally shown wearing the lionskin of fortitude, the successful artist is draped in the oxhide of hard work.

What are we to make of the total meaning of the painting? Allegorical as I think its intention was, Steen's picture cannot be translated into anything like a prose equivalent. Like most Dutch paintings, it is too complex, too remote, too elusive in its totality, for us fully to grasp. And in any case Steen probably did not expect viewers to extract a single, final message from the picture but instead left elements of the picture open for interpretation. We can identify the traditional associations of the things in the room and see much of the web that connects them. We can apply what we know about artists' studios and the training of painters. But there nevertheless remain elements of the picture that we do not fully understand, especially the identity of the girl and the

Figure 63
Jan Muller (Dutch,
1571–1628), after
Bartholomeus Spranger
(Flemish, 1546–circa
1611). *Minerva Crowning
a Young Artist*, circa
1600. Engraving, 24.5 ×
17.3 cm (9⅝ × 6¾ in.)
Vienna, Graphische
Sammlung Albertina
(HI 61)

role she is playing here. To reiterate: dressed this way, she cannot have been an apprentice. Lacking any specific attributes to identify her, she probably is not a muse or an allegory (except to the extent that she embodies practice, Exercitatio). Instead, she seems to be a young woman of a kind who is rarely pictured or documented but must have existed in some numbers, an amateur sent to a painter for training.

Having admitted the difficulties of translating a picture into prose, let me try a loose paraphrase of the main message of *The Drawing Lesson*:

> The history painter, a man of cultivation and worldly substance, perpetuates his art by teaching pupils. Possessing the knowledge and the necessary repertory of materials to do so, he gives drawing instruction to apprentices as well as to children of important families. Even an exquisitely dressed girl of high standing frequents the studio of such a painter, conferring honor on him and by implication on the art of painting. Yet this art, for all its nobility, is seductive and must be regarded soberly, in the light of the inevitable fate of all creatures.

Is this too heavy a burden of meaning for this delightful picture to bear? Is it too straight a message for the lighthearted Steen? I do not think so.

Steen had a serious side as a painter, despite the fact that comedy is his natural mode, and despite his famous nimble wit and appetite for the erotic. We see that side in the Getty painting. In that vein Steen painted a handful of other complex and successful pictures, including his debut as a painter of serious subjects, the 1655 portrait of a man on a stoop outside his house in Delft [FIGURE 8]. Whatever the meaning of the subsidiary figures and the actions in the picture, we can be confident that nothing satiric was intended by any of it. By 1660 or so Steen had painted an allegorical subject set in a grand windowed room like that of *The Drawing Lesson* [FIGURE 64]. Basing himself on a drawing by Holbein, Steen painted a scholar who is so absorbed in his studies that he cannot see that his time is almost up: death is literally at the door and the sands of his hourglass are running out. (It is held by a boy who is a younger version of the pupil in *The Drawing Lesson*.) A smiling figure in the background points out the moral, but not in fun. Steen treated other genre subjects with an absolutely straight face, especially the often-repeated *Grace Before the Meal*, and many biblical and historical subjects. When he tackles the representation of the core activity of his profession as an artist—drawing and its transmission through teaching—seriousness is just what we ought to expect.

That Steen can be straight-faced without being pedantic is one of the delights of his allegorical picture: the objects in *The Drawing Lesson* seem to be present naturally, to have their own beauty and their own subtle relationship with their surroundings, no matter how laden with traditional associations they are. Even more seductive are Steen's master and pupils, whose faces are full of animation and who play their parts so believably.

Figure 64
Jan Steen. *A Scholar in His Study with Death at the Door*, circa 1658–60. Oil on panel, 46.5 × 42.5 cm (18¼ × 16¾ in.). Prague, Narodni Galerie (DO-4151).

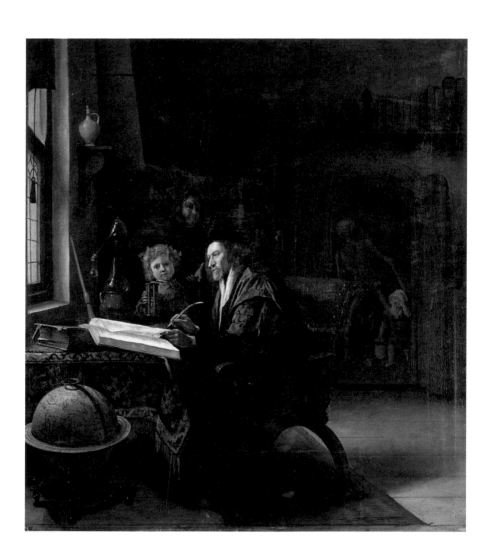

Since this book is intended primarily for non-specialists, footnotes have been dispensed with. For general readers who may wish to read more on Steen, there are general bibliographical remarks under each section. For specialists, further notes on specific matters are supplied page by page. Translations are mine.

Introduction

The literature on *The Drawing Lesson* is not extensive, although the picture is included in the standard works on Steen. A list of these citations follows, as well as the more substantial references to the picture in other book and articles. Further references to the painting are given under individual sections below. The provenance of the painting has been added to and brought up to date by Mariët Westermann in the entry by H. Perry Chapman for the Washington-Amsterdam exhibition (the final item in the following citations). Burton Fredericksen, the curator under whom the painting was bought by the Getty, has recently identified L.C. Desmarest (or Desmarets), an eighteenth-century owner.

John Smith, *A Catalogue Raisonné of the Works of the Most Eminent Dutch, Flemish, and French Painters . . . Part Four* (London, 1833), p. 12, no. 36; T. van Westrheene, *Jan Steen* (The Hague, 1856), p. 158, no. 348; C. Hofstede de Groot, *A Catalogue Raisonné of the Most Eminent Dutch Painters of the Seventeenth Century*, vol. 1 (London, 1907), p. 74, no. 247; Henry Havard, "Jan Steen," *L'Art et les Artistes* 11 (1910), p. 103, illus.; Abraham Bredius, *Jan Steen* (Amsterdam, 1927), p. 67, pl. 82; F. Schmidt Degener and H. E. van Gelder, *Veertig Meesterwerken van Jan Steen* (Amsterdam, 1926), p. 61;

C. H. de Jonghe, *Jan Steen* (Amsterdam, n.d.), p. 20; Horst Gerson, *Het Tijdperk van Rembrandt en Vermeer* (Amsterdam, 1952), p. 188; W. Martin, *Jan Steen* (Amsterdam, 1954), pp. 17, 81, pl. 5; *Jan Steen*, exh. cat. (Mauritshuis, The Hague, 1958). no. 27. Lyckle de Vries, *Jan Steen 'de kluchtschilder'* (Ph.D. diss., University of Groningen, 1977), p. 53, no. 81; Karel Braun, *Alle tot nu toe bekende schilderijen van Jan Steen* (Rotterdam, 1980), no. 182; Hessel Miedema, "Kunstschilders, gilde en academie: Over het probleem van de emancipatie van de kunstschilders in de Noordelijke Nederlanden van de 16de en 17de eeuw," *Oud Holland* 101 (1987), pp. 20–21, illus. and n. 156; Burton B. Fredericksen et al., *Masterpieces of Painting in the J. Paul Getty Museum*, rev. ed. (Malibu, 1995), no. 28; Franzsepp Würtenberger, "Galante Atelierszenen im 18. Jahrhundert und die Würde der Kunst," in *Maler und Modell*, exh. cat. (Staatliche Kunsthalle, Baden-Baden, 1969) (n.p., ill.); John Walsh, "Jan Steen's *Drawing Lesson* and the Training of Artists," *Source* 8–9 (1989), pp. 80–96; Leo Steinberg, "Steen's Female Gaze and Other Ironies," *Artibus et Historiae* 22 (1990), pp. 107–28; *Jan Steen: Painter and Storyteller*, exh. cat. (National Gallery of Art, Washington, D.C., 1996), no. 27.

Page 1

On Steen's painting technique, see Marigene H. Butler, "Appendix: An Investigation of the Technique and Materials Used by Jan Steen," in *Philadelphia Museum of Art Bulletin* 78 (1982–83), pp. 44–61. Mark Leonard examined the painting in 1992 and made the observations that follow.

> Steen used a solid, well-prepared and beveled oak panel of a kind that is entirely

normal for Dutch paintings of the period. There is a tan-gray colored ground applied on top of a white preparation, the same structure Butler observed in the contemporary *Doctor's Visit* in Philadelphia. This warm light ground infuses the picture with warm silvery tonality. The paints, which are pure and vibrant, were applied in relatively uncomplicated mixtures. There are few cracks, indicating that the ratio of pigment to oil medium was perfect. Although the painting exhibits a solid, straightforward technique, a variety of methods of applying paint can be seen, ranging from transparent glazes for the tapestry to opaque modeling for the flesh. The technique is wet-into-wet; this is seen in the boy's hair, for instance, where the strokes at the edge of the head were dragged through the still-wet gray of the background. The mottled appearance of the girl's skirt is caused by an inevitable increase in the transparency of the shadowed areas, which were first prepared with brown earth color over the yellow skirt, then strengthened by a scumble of yellow ochre or raw sienna on top of the brown earth; when the scumble became more translucent with time, the preparation of the shadows and some changes (mainly around the girl's hand) were revealed.

A FAMILIAR FACE

For the reevaluation of Steen's biography and character, see de Vries, *Jan Steen 'de Kluchtschilder'*; de Vries, *Jan Steen, de schilderende Uilenspiegel* (Weert, 1976); H. Perry Chapman, "Jan Steen's Household Revisited," *Simiolus* 20 (1990/91), pp. 183–96; Chapman, "Persona and Myth in Houbraken's Life of Jan Steen," *Art Bulletin* 75 (1993), pp. 135–50; and Chapman, "Art and Life in the Paintings of Jan Steen," in *Jan Steen*, Washington, pp. 11–24.

PAGE 10

The documents for Steen's life were published in A. Bredius, *Jan Steen* (Amsterdam, 1927). For Steen and Knupfer, see Baruch D. Kirschenbaum, *The Religious and Historical Paintings of Jan Steen* (New York, 1977), pp. 29–31. For Steen, Delft, and de Hooch, see Peter C. Sutton, *Pieter de Hooch* (Oxford and New York, 1980), pp. 24–25.

PAGE 12

Recently Marten Jan Bok has added to what is known about Steen's family and his stay in Warmond and reexamined the entire biography with particular atttention to Steen's financial fortunes and the fluctuations of the economy: "The Life of Jan Steen," *Jan Steen*, Washington, pp. 25–38.

PAGE 14

For Steen's drawing, see Peter Schatborn, *Dutch Figure Drawings from the Seventeenth Century*, exh. cat. (Rijksmuseum, Amsterdam, 1981), p. 79. Jane Shoaf Turner kindly let me see the entry she has prepared for *The Trial of Moses* in her forthcoming catalogue of Dutch drawings in the Ashmolean Museum.

PAGE 18

For van Mieris, see Otto Naumann, *Frans van Mieris the Elder*, 2 vols. (Doornspijk, 1981); for the Leiden School, see *Leidse Fijnschilders, van Gerrit Dou tot Frans van Mieris de Jonge, 1630–1760*, exh. cat. (Stedelijk Museum 'de Lakenhal,' Leiden, 1988).

PAGE 22

Reynolds's critique of Steen: Sir Joshua Reynolds, *A Discourse Delivered to the Students of the Royal Academy* (London, 1775), pp. 30–31.

PAGE 24

For Steen's theatricality, intentions, and the role of comedy in moral instruction, see A. Heppner, "The Popular Theatre of the Rederijkers in the Work of Jan Steen and His Contemporaries," *Journal of the Warburg and Courtauld Institutes*

3 (1939–40), pp. 22–48; S. J. Gudlauggson, *Comedianten bij Jan Steen en zijn tijdgenoten* (The Hague, 1945), trans. as *The Comedians in the Work of Jan Steen*, intro. by J. G. van Gelder (Soest, 1975); the essays by Chapman cited above; and Mariët Westermann, "Comic Fictions," and E. de Jongh, "Jan Steen, So Near and Yet So Far," both in *Jan Steen*, Washington, pp. 53–68 and 39–52. The quote about TV comedy is from Chapman, "Jan Steen's Household." Critical writing on the intended functions of Dutch paintings has become voluminous. For an up-to-date evaluation as it applies to Steen, see the article by E. de Jongh in the Washington catalogue just cited; also by the same author, "Die 'Sprachlichkeit' der Niederländischen Malerei im 17. Jahrhundert," in *Leselust, Niederländische Malerei von Rembrandt bis Vermeer*, exh. cat. (Schirn Kunsthalle, Frankfurt, 1993), pp. 23–34. For a judicious survey written a decade ago, Peter C. Sutton, *Masters of Seventeenth-Century Dutch Genre Painting*, exh. cat. (Philadelphia Museum of Art, 1984), pp. xiii–lxxviii.

PICTURING THE WORKSHOP

The literature on images of artists' studios and on portraits of artists is partly overlapping. The most systematic modern study is Hans-Joachim Raupp, *Untersuchungen zu Künstlerbildnis und Künstlerdarstellung im der Niederlanden in 17. Jahrhundert* (Hildesheim, Zurich, and New York, 1984). See also Götz Eckardt, *Selbstbildnisse niederländische Maler des 17. Jahrhunderts* (Berlin, 1971) and Ludwig Goldscheider, *Fünfhundert Selbstporträts von der Antike bis zur Gegenwart* (Vienna, 1936). For an iconographical index, H. van Hall, *Portretten van nederlandse beeldende kunstenaars* (Amsterdam, 1963). The remarkable catalogue of the exhibition *La peinture dans la peinture* (Musée des Beaux-Arts, Dijon, 1982–83), with essays by Pierre Georgel and Anne-Marie Lecoq, is wide-ranging and highly readable. The topic has proven popular among organizers of exhibitions and has stimulated useful catalogues essays, including

G. Th. H. Lemmens, "De schilder in zijn atelier" in *Het schildersatelier in the nederlanden 1500–1800* (De Waag, Nijmegen, 1964) and reprinted in *De schilder en zijn wereld* (Stedelijk Museum 'het Prinsenhof,' Delft, 1964), pp. 14–32; Hans-Joachim Raupp, "Selbstbildnisse und Künstlerportraets—ihre Function und Bedeutung" in *Selbstbildnisse und Künstlerportraets von Lucas van Leyden bis Anton Raphael Mengs* (Herzog Anton-Ulrich-Museum, Braunschweig, 1980), pp. 7–35; Pierre Georgel, Janine Baticle, and Nicole Willk-Brocard, *Technique de la peinture: l'atelier*, Dossiers du département des peintures 12 (Paris, Musée du Louvre, 1976); Siegmar Holsten, *Das Bild des Künstlers. Selbstdarstellungen* (Kunsthalle, Hamburg, 1978); *Maler und Modell* (Staatliche Kunsthalle, Baden-Baden, 1969), and John Walsh, *Portrait of the Artist* (New York, The Metropolitan Museum of Art, 1971). See also Michael Levey, *The Painter Depicted: Painters as a Subject in Painting* (London, 1981), an especially acute essay, and Franzsepp Würtenberger, "Das Maleratelier als Kultraum im 19. Jahrhundert," *Miscellanea Bibliotecae Herzianae zu Ehren von Leo Bruhns, Fransgraf Wolff Metternich, Ludwig Schudt* (1961) pp. 502–13.

PAGE 27

For Heemskerck, Rainald Grosshans, *Maerten van Heemskerck: die Gemälde* (Berlin, 1980), pp. 195–201, no. 75; for Gossaert, *Jean Gossaert dit Mabuse*, exh. cat. (Museum Boymans-van Beuningen, Rotterdam, and Musée communal Groeninge, Bruges, 1965), pp. 107–109, no. 12; Dijon, *La Peinture dans la peinture*, pp. 67, 114–16.

PAGE 28

For the drawing attributed to Valckert, Eric J. Sluyter, "Venus, Visus et Pictura," *Nederlands Kunsthistorisch Jaarboek* 42–43 (1992–93), pp. 337–396.

PAGE 32

For Hoogstraeten's "keurlijke natuerlijkheid," Samuel van Hoogstraeten, *Inleyding tot*

de hooge schoole der schilderkonst: Anders de zichtbaere werelt (Rotterdam, 1678), reprint Soest, 1969, p. 238; Sutton, *Masters of Dutch Genre*, pp. xix–xxi.

PAGE 33

For Ostade, Schatborn, *Dutch Figure Drawings*, p. 27.

PAGE 35

For Molenaer, Raupp, *Untersuchungen*, pp. 282–83. For Musscher, Margarita Russell, "The Artist in His Studio, a Self Portrait by Michiel van Musscher," *Apollo* 127 (1988), p. 12.

PAGE 37

For Codde, Raupp, *Untersuchungen*, pp. 330–31. For van Mieris, Naumann, *Frans van Mieris*, vol. 2, p. 15, cat no. 12, and p. 18, cat. no. 19.

PAGE 38

For Geeraerdts and images of the impoverished artist, Holsten, *Das Bild des Künstlers*, p. 64. The Elsheimer drawing is published by Werner Sumowski, "The Artist in Despair: A New Drawing by Adam Elsheimer," *Master Drawings* 33 (1995), pp. 152–56. For Pictura, Cesare Ripa, *Iconologia, of uytbeeldingen des verstands* (Amsterdam, 1644), pp. 452–53; J. G. van Gelder, *De Schilderkunst van Jan Vermeer* (with a commentary by J. A. Emmens) (Utrecht, 1958).

PAGE 40

For Vanitas in the studio, Raupp, *Untersuchungen*, pp. 266–88.

THE TRAINING OF A PAINTER

There is no comprehensive study of the training of Dutch artists. A good starting point in English is the exhibition catalogue *Children of Mercury: Education of Artists in the Sixteenth and Seventeenth Centuries* (Bell Gallery, Brown University, Providence, 1984), organized by Jeffrey Muller with essays by his students. Dated but in English is W. Martin, "The Life of a Dutch Artist

in the Seventeenth Century," *Burlington Magazine* 7 (1905), pp. 125–28, 416–27; 8 (1905–6), pp. 13–24; 10 (1906–7), pp. 144–54; 363–370; 11 (1907) pp. 357–69. Major contributions have been made recently in articles by Hessel Miedema, especially "Over vakonderwijs aan kunstschilders in de Nederlanden tot de zeventiende eeuw," *Leids Kunsthistorisch Jaarboek* 5/6 (1988–87), pp. 268–83, and more generally in his book *Kunst historisch* (Maarssen, 1989). There is an up-to-date essay by Peter Schatborn in *Dutch Figure Drawings*, pp. 11–32. Among the more useful recent articles are Marten J. Bok, "'Nulla dies sine linie': De opleiding van schilders in Utrecht in de eerste helft van de zeventiende eeuw," *De zeventiende eeuw* 6–1 (1990), pp. 58–68; and E. A. de Klerk, "'Academy-beelden and 'teeken-schoolen' in Dutch Seventeenth-Century Treatises on Art," *Leids Kunsthistorisch Jaarboek* 5/6 (1986/87), pp. 283–88. Lemmens's essay "De schilder in zijn atelier" in *De schilder in zijn wereld* is still worthwhile. On contracts with pupils, see Ronald de Jager, "Meester, leerjongen, leertijd: Een analyse van zeventiende-eeuwse Noord-Nederlandse leerling-contracten van kunstschilders, goud en zilver-smeden," *Oud Holland* 104 (1990), pp 69–111. On drawing instruction for laypeople, see Wolfgang Kemp, '. . . *einen wahrhaft bildenden Zeichenunterricht überall einzuführen.' Zeichnen und Zeichenunterricht der Laien 1500–1870; ein Handbuch* (Frankfurt a.M., 1979). On the role of the guilds and the social role of artists, see Hessel Miedema, "Kunstschilders, gilde en academie: over het probleem van de emancipatie van de kunstschilders in de Noordelijke Nederlanden van de 16de en 17 de eeuw," *Oud Holland* 101 (1987), pp. 1–34. See also the fundamental study by J. Michael Montias, *Artists and Artisans in Delft: A Socio-Economic Study of the Seventeenth Century* (Princeton, 1982).

PAGE 44

For Hoogstraeten on artists' motives, *Inleyding*, pp. 345–61; Seneca, *De Beneficiis*, Book 2, Ch. 23.

81

PAGE 45
For van Mander on training, Hessel Miedema, "Over vakonderwijs," pp. 269–77.

PAGE 48
For Hoogstraeten on drawing, *Inleyding*, pp. 26–36; "nice faces," p. 26.

PAGE 50
On the Bloemaert drawing book, see Peter Schatborn, *Dutch Figure Drawings*, pp. 16–17; and J. Bolten, *Het Noord- en Zuidnederlandse tekenboek, 1650–1750* (Ter Aar, 1979), pp. 26–29.

PAGE 51
For Goeree, Wilhelmus Goeree, *Inleydingh tot de Alghemeene Teyckenkonst . . .* (Middelburgh, 1668), pp. 34–35.

PAGE 52
On erasable tablets, Ernst van de Wetering, "Verdwenen tekeningen en het gebruik van afwisbare tekenplankjes en 'tafeletten.'" *Oud Holland* 105 (1991), pp. 210–27. On the studio paintings of Vaillant, Peter C. Sutton, *Dutch and Flemish Seventeenth-Century Paintings: The Harold Samuel Collection* (London, 1992), no. 72.

PAGE 55
On group instruction, Miedema, "Kunstschilders," pp. 1–30; de Klerk, "Academybeelden"; and Bok, "Nulla Dies." On mannequins, P. T. A. Swillens, "Beelden en ledepoppen in de schilderkunst," *Maandblad voor Beeldende Kunst* 23 (1947), pp. 247–58, 277–90; E. F. van der Grinten, "Le cachelot et le mannequin, deux facettes de la réalité dans l'art hollandais de seizième et du dix-septième siècles," *Nederlands Kunsthistorisch Jaarboek* 13 (1962), pp. 149–79; Lemmens in *De schilder in zijn wereld*, pp. 21–22. For ter Borch's letter, Gudlaugsson, *Gerard ter Borch*, vol. 2, pp. 15–16.

PAGE 56
For a survey of the situation of women painters in the Netherlands, Els Kloek, "The Case of Judith Leyster: Exception or Paradigm?," in *Judith Leyster, a Dutch Master and Her World*, exh. cat. (Worcester Art Museum, Mass., and Frans Halsmuseum, Haarlem, 1993), pp. 55–68. On Metsu's painting, Franklin W. Robinson, *Gabriel Metsu 1629–1667* (New York, 1974), pp. 48–49. The eminent Utrecht painter Gerard van Honthorst was the teacher of well-born women; see Marten J. Bok and Jos de Meyere, "*Schilderes aan haar ezel*. Nieuwe gegevens over het schilderij van Gerard van Honthorst," *Maadblad Oud-Utrecht* 58 (1985), pp. 298–303.

PAGE 58
On Catherina Backer, C. Willemijn Fock, "De stillevens van Catherina Backer of de verdrijving van de melancholie," *Leids Jaarboek* 72 (1980), pp. 73–86.

PAGE 59
For the "Ochtervelt" studio scene, Susan Donohue Kuretsky, *The Paintings of Jacob Ochtervelt* (Oxford, 1979), p. 102, no. D-9.

ANOTHER LOOK AROUND

Several attempts have been made to explain Steen's intentions in *The Drawing Lesson*. My own proposal a few years ago of an allegorical reading of the picture drew extensively on individual observations published earlier by others ("Jan Steen's *Drawing Lesson* and the Training of Artists," *Source* 8–9 [1989], pp. 80–86). There followed a very different interpretation by Leo Steinberg ("Steen's Female Gaze and Other Ironies," *Artibus et Historiae* 22 [1990], pp. 107–28). Steinberg thinks that both pupils are inattentive to their lesson: the girl is looking across at the genitals of the male statuette with newly awakened wonder and the boy is looking at the girl with unrequited puppy love. He sees "the moment depicted" as one of initiation into sexual knowledge. In his view Steen is poking fun at the attributes, appearance, and behavior of the master, whom he portrays as a pretentious pedant who can't see the real education going on. Steinberg is a dazzling writer and has many

good observations about the picture, but in my view neither the sexuality or the irony he perceives have anything to do with Steen's intentions, or indeed with a seventeenth-century frame of reference. They are twentieth-century psychosexual and literary speculations: to quote de Jongh on another painting by Steen, "these meanings have been parachuted into the picture" (de Jongh, "Jan Steen, So Near and Yet So Far"). The pupils may be looking past the master, but I doubt they are meant to be focused on anything specific. Trying to find the exact direction in which people in pictures are looking is a famously difficult business: witness the tour guides everywhere who point out the portrait whose eyes follow you around the room. Attributing specific emotional and psychological content to facial expressions in seventeenth-century paintings is also hazardous. (Worth reading in this context are P. J. Vinken and E. de Jongh, "De boosardigheid van Hals' regenten en regentessen," *Oud Holland* 78 [1963], pp. 1–24, where an extreme position is taken, and H. van de Waal, "De Staalmeesters en hun legende," *Oud Holland* 71 [1956], pp. 61–107, reissued as "*The Syndics and Their Legend*," in *Steps Toward Rembrandt* [Amsterdam], 1974, pp. 247–92.)

PAGE 62
For the standing of history painting, Albert Blankert, "General Introduction," *Gods, Saints and Heroes: Dutch Painting in the Age of Rembrandt*, exh. cat. (National Gallery of Art, Washington, D.C., 1980), pp. 15–33. For Hoogstraeten on the hierarchy of genres, *Inleyding*, pp. 75–87.

PAGE 63
On music, Hans-Joachim Raupp, "Musik im Atelier," *Oud-Holland* 92 (1978), pp. 106–28. On the fashion for kimonos, A. M. Lubberhuizen-van Gelder, "'Japansche Rocken'," *Oud-Holland* 62 (1947), pp. 137–152; Seymour Slive, "A Family Portrait by Nicolaes Maes," *Annual Report of the Fogg Art Museum* (Cambridge, 1957–58), pp. 32–39. For advice about the materials in the studio, I am grateful to Marjorie Cohn.

PAGE 66
On van Mander and the *effecten*: Karel van Mander, *Den grondt der edel vry schilder-const* (Haarlem, 1604), ch. 4, "Wtbeeldinge der Affecten"; ed. with commentary by Hessel Miedema, 2 vols. (Utrecht, 1973), vol. 1, pp. 156–83, and vol. 2, 306–17 and 492–511. On the Vittoria statuette and Steen: W. R. Valentiner, "Alessandro Vittoria and Michelangelo," *Art Quarterly* 5 (1942), pp. 148–57.

PAGE 67
The armature in Rembrandt's drawing was pointed out in a lecture by Julius Held.

PAGE 68
For the Adriaen van de Velde statuette, see Franklin W. Robinson, *Gabriel Metsu*, p. 82, n. 84; Sjraar van Heugten, "Grazende modellen," in *Meesterlijk vee, Nederlandse Veeschilders 1600–1900*, exh. cat. (Dordrechts Museum, 1990), p. 27. For the foreshortened ox of Pausias, Pliny the Elder, *Nat. Hist.* 25, pp. 126–27 (trans. by K. Jex-Blake, *The Elder Pliny's Chapters on the History of Arts* [Chicago, 1976], p. 153); for Myron's cow, van Mander, *Grondt* 9, "Dieren," 42–46; Miedema ed., vol. 1, pp. 233–34, and vol. 2, pp. 568–69.

PAGE 70
For Rembrandt's inventory in English, Kenneth Clark, *Rembrandt and the Italian Renaissance* (New York, 1966), pp. 193–209, nos. 178, 330.

PAGE 71
For the Five Senses in atelier pictures, Raupp, *Untersuchungen*, pp. 326–29.

PAGE 73
For the Dou, see Jan Emmens, "Natuur, Onderwijzing, en Oefening: Bij een drieluik van Gerrit Dou," *Album Dicipulorum J. G. van Gelder* (Utrecht, 1963), pp. 125–36, trans. and abr. as "A Seventeenth-Century Theory of Art: Nature and Practice," *Delta* (Summer 1969), pp. 30–39.

PAGE 74

Thomas Kaufmann brought the engraving by Muller to my attention; for its interpretation, see Thomas Da Costa Kaufmann, "The Eloquent Artist: Towards an Understanding of the Stylistics of Painting at the Court of Rudolf II," *Leids Kunsthistorisch Jaarboek* 1 (1982), pp. 126–27. On the idea of open-ended interpretation, Chapman, "Art and Life," and Westermann, "Comic Fictions."

PAGE 76

The "Burgomaster of Delft" has recently been given a strained political interpretation: Sheila D. Muller, "Jan Steen's *A Burgher of Delft and His Daughter*: A Painting and Politics in Seventeenth-Century Holland," *Art History* 12 (1989), pp. 268–97; for a response, de Jongh, "Jan Steen, So Near and Yet So Far." The Steen *Scholar* in Prague: de Vries, *Jan Steen, de schilderende Uilenspiegel*, p. 21, and Steinberg, "Steen's Female Gaze," pp. 107, 124 n. 2.

Foldout

Jan Steen (Dutch, 1626–1679). *The Drawing Lesson*, circa 1665. Oil on panel, 49.3 × 41 cm (19⅜ × 16¼ in.). Los Angeles, J. Paul Getty Museum (83.PB.388).

ACKNOWLEDGMENTS

This dish has been on the stove for such a long time that many cooks have added ingredients and given advice to the chef. It began with a lecture, "Two Paintings by Jan Steen," at the Getty Museum and the Philadelphia Museum of Art in 1984. I gave a brief, specialized paper on *The Drawing Lesson* at a symposium at Columbia University in March 1989 in honor of Rudolf Wittkower that was published that year in *Source* as "Jan Steen's *Drawing Lesson* and the Training of Artists." A term at Oxford in 1992 gave me the chance to write this book, thanks to the willingness of the Getty Trust to let me go and the superb ability of my Associate Directors Deborah Gribbon and Barbara Whitney to run the Getty Museum in my absence. In Oxford I enjoyed the kindness of Christopher White and the hospitality of the Department of Western Art and the Heberden Coin Room of the Ashmolean Museum. The staff of the Rijksmuseum voor Kunsthistorische Documentatie in The Hague dealt generously with more than my usual demands on its unrivaled library and photograph collection, in particular Gerbrand Cotting, Fred Meijer, and Willem Rappard. My hideout in Los Angeles was the library of the Getty Center for the History of Art and the Humanities, whose staff under Anne-Mieke Halbrook made my life easier in a hundred ways.

I have had especially profitable conversations and exchanges of mail with Mariët Westermann, Perry Chapman, Leo Steinberg, Lyckle de Vries, Christopher White, Sebastian Dudok van Heel, Mark Leonard, Jane Shoaf Turner, Marjorie Cohn, Marten Jan Bok, and Gary Schwartz. I was fortunate in receiving suggestions and material help from various colleagues, particularly W.K. and K. van Dam, Colin Eisler, Burton Fredericksen, Ivan Gaskell, Julius S. Held, Eddy de Jongh, Thomas Da Costa Kaufmann, Alison Kettering, Peter Mellor, Otto Naumann, Joaneath Spicer, Pjer Strolenberg, Werner Sumowski, and Arthur Wheelock.

Thomas Kren and Walter Liedtke gave the text close and extremely helpful readings. Amy Fisk provided every kind of aid in preparing the manuscript. My editor Mark Greenberg, helped by Mollie Holtman, made a great many improvements to the text; Kimberly Palumbo bird-dogged the illustrations; Jeffrey Cohen produced an elegant design with a minimum of fuss; and Stacy Miyagawa saw the book through the presses. To all I am grateful.—JW